1,000,000 Books

are available to read at

Forgotten Books

www.ForgottenBooks.com

Read online
Download PDF
Purchase in print

ISBN 978-1-332-26363-9
PIBN 10306148

This book is a reproduction of an important historical work. Forgotten Books uses state-of-the-art technology to digitally reconstruct the work, preserving the original format whilst repairing imperfections present in the aged copy. In rare cases, an imperfection in the original, such as a blemish or missing page, may be replicated in our edition. We do, however, repair the vast majority of imperfections successfully; any imperfections that remain are intentionally left to preserve the state of such historical works.

Forgotten Books is a registered trademark of FB &c Ltd.
Copyright © 2018 FB &c Ltd.
FB &c Ltd, Dalton House, 60 Windsor Avenue, London, SW19 2RR.
Company number 08720141. Registered in England and Wales.

For support please visit www.forgottenbooks.com

1 MONTH OF FREE READING

at
www.ForgottenBooks.com

By purchasing this book you are eligible for one month membership to ForgottenBooks.com, giving you unlimited access to our entire collection of over 1,000,000 titles via our web site and mobile apps.

To claim your free month visit:
www.forgottenbooks.com/free306148

* Offer is valid for 45 days from date of purchase. Terms and conditions apply.

English
Français
Deutsche
Italiano
Español
Português

www.forgottenbooks.com

Mythology Photography **Fiction** Fishing Christianity **Art** Cooking Essays Buddhism Freemasonry Medicine **Biology** Music **Ancient Egypt** Evolution Carpentry Physics Dance Geology **Mathematics** Fitness Shakespeare **Folklore** Yoga Marketing **Confidence** Immortality Biographies Poetry **Psychology** Witchcraft Electronics Chemistry History **Law** Accounting **Philosophy** Anthropology Alchemy Drama Quantum Mechanics Atheism Sexual Health **Ancient History Entrepreneurship** Languages Sport Paleontology Needlework Islam **Metaphysics** Investment Archaeology Parenting Statistics Criminology **Motivational**

400 PAGES OF ILLUSTRATIONS.

AN HISTORICAL GUIDE

TO

FRENCH
Interiors, Furniture,

DECORATION,

Woodwork & Allied Arts

DURING

The last half of the Seventeenth Century,

THE WHOLE OF THE

EIGHTEENTH CENTURY,

And the earlier part of the Nineteenth,

BY

THOMAS ARTHUR STRANGE.

Published by McCORQUODALE & CO., Limited, 40, Coleman Street, London, E.C. 2.
Also at Glasgow and Newton-le-Willows.

PRICE 30s. NET.

ENTERED AT STATIONERS' HALL.

NK
2049
S8
cop. 2

BOARD OF EDUCATION

(*VICTORIA AND ALBERT MUSEUM*).

TRUSTEES OF WALLACE COLLECTION

(*HERTFORD HOUSE*).

A great number of the Illustrations in this Book have been introduced with the Special permission of the above Authorities.

Permission has also been granted by the Directors of several of the French Palaces and Museums (Louvre, Versailles, etc.).

The right to reproduce other Photographs (Interiors) has been purchased.

INDEX.

Balconies, 47.
Barometers, 348.
Bedheads, 129, 234.
Bedsteads, 131, 308, 340, 370, 371, 389, 399.
Borders and Friezes, 84, 85, 88, 162, 376, 385 (49, 50, 51, 52, 53).
Brackets, 231, 233, 311.
Bureaux, 309, 319, 323, 342, 343.
Cabinets, 4, 8, 9, 23, 76, 144, 148, 149, 150, 152, 161, 346, 351, 396 (64).
Candlesticks, 112, 270, 271, 384.
Canopies, 235.
Candelabra, 134, 142, 143, 144, 339, 344, 355, 365 (289, 303).
Carvings, 39, 57, 154, 172, 176, 186, 187, 188, 246, 247, 254.
Ceilings, 71, 78, 79, 80, 81, 83, 86, 300, 307, 310, 354, 359.
Chairs, 28 to 31, 161, 174, 180 to 185, 330, 334, 366, 367, 374, 377, 378, 390, 391.
Chests of Drawers, 250.
Chimneypieces, 11 to 16, 56 to 63, 66 to 69, 87, 89, 108 to 111, 118 to 123, 172, 173, 236, 237, 238, 293, 300, 302, 303, 337, 338, 379, 380, 381.
China Showcases, 349.
Cisterns, 272.
Clocks, 114 to 117, 140, 146 to 149, 153, 154, 161, 165, 260, 310, 322, 364, 368.
Coaches, 139, 329.
Coach Furniture, 327, 328.
Commodes, 23, 141, 148, 176, 252, 275, 320, 321, 322, 344, 345, 346, 348, 349, 382, 383, 385, 397.
Console Tables, 75, 77, 132, 150, 151, 152, 178, 179, 230, 261, 262, 264, 285, 305, 314, 341, 380.
Damask, 42.
Decanters, 271.
Decorative Panels, 18, 19, 33, 90 to 104, 106 to 108, 126 to 129, 193 to 208, 246, 248, 252 to 255, 269, 314, 335.
Doors, 7, 70, 155 to 160, 224, 301.
Doorways, 6, 7, 17, 54 and 55, 170, 171, 223.
Dressing Tables, 370.
Fancy Tables, 323.
Figure Decoration, 316, 317.
Finials, 307 to 311.
Fire Backs, 66, 68, 109 to 111.
Fire Dogs, 68, 69, 113, 188.
Fountains, 36, 332.
Frames, 1, 276, 278 to 285, 362.
Girandoles, 133, 228, 229, 232.
Guéridons, 352.
Handles, 242.
Initial Letters, 257, 259, 264, 267 to 269, 272, 275, 277, 278 279, 280, 281 to 283, 285, 288.
Inlays, 326, 353.

Interiors, 5, 8, 26, 38, 40, 41, 45, 145, 164, 166, 167, 169, 315, 318, 324, 325, 336, 337, 356, 358, 360, 361, 364, 368, 369, 372, 373, 388, 392, 393, 398.
Ironwork, 171, 225, 226, 227, 290, 291, 312, 313, 332.
Lampadaire, 394, 395.
Lamps, 266.
Lamp Stands, 289.
Marriage Caskets, 153.
Medallier, 234, 253.
Mirrors, 75, 77, 133, 236, 261, 262, 293, 305.
Mouldings, 136.
Music Stands, 351.
Ormolu Mounts, 242, 243, 364.
Ornament, 17, 21, 24, 25, 34, 35, 44, 46, 83, 122, 123, 163, 174, 175, 273 to 275, 284, 312, 386, 399, 400.
Overdoors, 124, 125, 246, 247, 299.
Pavements, 48.
Pedestals, 75, 77, 108, 162, 165, 311.
Picture Frames, 270, 326.
Pictures and Illustrations, 1, 2, 3, 240, 246, 254, 256, 276 to 279, 282, 283, 286, 287, 288, 334.
Salt Cellars, 266, 268.
Screens, 10, 151, 241, 371.
Secretaire, 347, 348, 350.
Sedan Chairs, 105, 113, 175, 329.
Sepulchral Monuments, 263.
Settees and Sofas, 265, 331, 366, 375, 378, 394, 395.
Side Tables, 65, 151, 264.
Sideboards, 65.
Sides of Rooms, 61, 72, 73, 74, 82, 88, 222, 232, 248, 258, 259, 260, 261, 262, 264, 265, 292, 294, 295, 296, 297, 298, 338, 341, 342, 355, 357, 376.
Sledges, 329.
Snuff Boxes, 138, 265, 268.
Staircases, 37, 306.
Statues, 34, 35, 333.
Stools, 37.
Stoves, 304.
Surtouts, 267.
Sword Handles, 271.
Tables, 10, 151, 163, 252, 366, 397.
Tapestry, 36, 37, 209 to 221.
Turnings, 30, 31.
Valances, 130.
Vases, 39, 134, 135, 313, 387.
Velvets, 43.
Wardrobes, 249, 251.
Watch Cases, 138, 266.
Weaving, 189 to 192.
Wine Coolers, 264.
Writing Tables, 9, 146, 147, 339, 340, 341, 382, 383.

Authors and Painters.

	PAGE		PAGE
Babel, P. E.	273 to 276, 278, 279, 280, 281, 282, 283, 285	Le Brun, Chas.	33, 36, 37, 44
Barbet, I.	11 to 16	Le Clerc	175
Berain	90 to 112	Le Jeune, J. M. Moreau	364
Berthault	353	Le Moyne, Francis, and Audran	254, 256
Blondel	289 to 295, 311 to 313	Le Pautre, J.	49 to 89
Bosse, Abraham	8	Le Prince	355
Boucher	286 to 288, 334	Le Roux, J. B.	244, 245
Boule, A. Charles	140 to 144, 146 to 153	Loir, Nicholas	46
Bourchardon	316, 317	Mansart	170, 171, 236 to 238
Briseux	296 to 303	Marot	113 to 139, 166 to 169
Chamblin	239	Meil, J. W.	285
Cotelle and Audran	248	Meissonier	257 to 272
Cressent	247	Mignard, Paul	34, 35
Cressent and Audran	252, 253	Natoire, Chas. J.	282
D'Avilier	47, 48	Nilson, J. E.	284
De Cuvilles, Francois	304 to 310	Normond, Chas.	387, 400
Desprez	376	Oppenord	221 to 227
De Wailley, Chas.	359 to 361	Oudry, Jean-Baptiste	209 to 220
Eissen, Chas.	255, 284	Patte, M.	337, 338
Fragonard	363	Percier and Fontaine	386, 389, 392, 393
Francart, J.	155 to 160	Pineau	228 to 235
Gillot	202 to 208	Poussin	27
Gravelotte	275 to 285	Rottière, Jean Siméon Rousseau de la	354, 355
Greuze, J. B., and Nilson, J. E.	362	Roubo	340, 341
Lajoue	240	Salembier	376
Lalonde	371, 378 to 384	Vouet, Simon (Louis XIII.)	1, 2, 3
Lancret and Audran	246	Watteau	193 to 201
Lancret, N.	276, 277		

Palaces and Museums.

	PAGE		PAGE
Chateau de Chantilly	324	Petit Trianon	356, 368, 369, 373
Fontainebleau	5, 6, 7, 314, 315, 356, 357, 358	Versailles	318, 368, 372
Galerie d'Apollon (Louvre)	145	Victoria and Albert Museum	241, 344, 345, 346, 347, 348, 349, 351
Grand Trianon	398		
Hotel Cluny	9	Wallace Collection	161, 164, 165, 319, 320, 322, 342, 343, 344, 349, 352,
Musée de Louvre	325, 326		

Louis XIII. **SIMON VOUET.** First Half 17th Century.

Simon Vouet was born in 1590 and died in 1649. He is regarded as the promoter of the great art movement in France founded on the Renaissance. He visited Italy and studied there the works of some of the great artists, including Paul Veronese, Valentin, and Caravaggio. On his recall to Paris by Louis XIII., in 1627, Vouet became principal painter to the King, and had apartments allotted to him at the Louvre. He was the master of Le Brun, Pierre Mignard, Le Sueur, and many others. While in Italy Louis XIII. had already accorded him a pension. He was for a long time employed on making designs for tapestries. He also gave lessons to the King in crayon drawing. He is regarded as the founder of the French school. As he was one of the designers of tapestries, I have thought it best to show one or two engravings from his works to give some idea of his style. He was a prodigious worker, and a great number of his works have been engraved. They have been published in a work called "Ouvre de Vouet." There is a copy at the Victoria and Albert Museum which appears to have belonged to Sir Joshua Reynolds. The designs in it are mostly of religious subjects, and are in a fine, bold, and well-proportioned style. It includes at the end another work of his called " Livre de Diverses Grotesques Peintes dans le Cabinet et Bains de la Reyne Regente au Palais Royal." An eminent writer on decorative art says of Vouet, having no doubt these last designs in his mind:—"He makes for the first time in French Renaissance that abundant use of floral detail in association with more conventional scroll work, which becomes by and by a characteristic of the period of the 'Grand Monarque.' One sees in him, too, the forerunner of Le Pautre and Berain, both of whom he seems to have influenced. He was, in fact, the precursor of the style Louis XIV."

Louis XIII. **SIMON VOUET.** First Half 17th Century.

Amour et Psyché.

Louis XIII. succeeded Henry IV. in 1610 and died in 1643. Many Chateaux were built during his reign, but the style is largely a continuation of that of Henry IV. Although it is not within the province of this work to mention artists who were purely painters or sculptors independently of being decorative artists, I will mention a few well-known names, as there is always an uncertainty as to whether they were not thus employed, nearly all artists of those days accepting commissions to paint ceilings, for instance. It is said that the reigns of Henry IV. and Louis XIII. were not very rich in great works of art, but the Palais du Luxembourg was built by Salomon de Brosse, and Jacques Lemercier built the Palais Cardinal—now the Palais Royal. The latter was built for Cardinal Richelieu, and was so lavishly furnished and decorated that it attracted the attention of Louis XIII., with the result that the Cardinal, in order to appease the King, made him a present of it—recalling what Cardinal Wolsey did with Hampton Court Palace. After the death of Louis XIII. the ex-Queen Anne of Austria resided there, hence its name—the Palais Royal.

Mansart designed the Bibliotheque National. He was the inventor of Mansart roofs. The oldest parts of Paris were built during this period, and from which also date the older private mansions, their peculiarity being that the fronts rise from enclosed courts, entered from very handsome gateways having the escutcheon over the centre, a great feature at this period. Nicholas Pouissin (1594-1654) and Claude Lorrain (1600-1682) belong to this period, also Eustache Le Sueur (1617-1655).

Louis XIII. **SIMON VOUET.** First Half 17th Century.

The Toilet of Venus.

The cabinets on page 4 were made in oak, sometimes in ebony and other woods, and had inlays of bone, ivory, mother-of-pearl, etc. The influences seem to have been German or Flemish. Abraham Bosse was born at Tours in 1611 and died in 1678. He was a painter, architect, engraver, and etcher. At the formation of the "Académie Royale de Peinture" in 1648 he was made Professor of Perspective. The chimneypieces I have illustrated of Barbet's are engraved by him (1733). The interior I have shown is one of a series illustrative of the manners of the period. It was usual for royalty and people of quality to receive their guests while seated in bed, and thus we have one of the reasons why beds of this and later periods were so ornate.

Salomon De Brosse, mentioned above, was born about 1560 and died in 1626. He was a nephew of Androuet du Cerceau. He was appointed architect to Maria de' Medici, queen of Henry IV. On page 5 is an illustration of a room in the Louis XIII. style at Fontainebleau. This palace owes its magnificence to Francis I., who converted it from a mediæval fortress. Francis I. was a great admirer of Italian art, and employed a great number of Italians at Fontainebleau. There was established what is called the school of Fontainebleau, founded on the style of Giulo Romano, and it is in this style that a great part of the interior of the palace is carried out. Henri IV., who died in 1610, made considerable additions. In the room illustrated is a mirror of Venetian glass reputed to be the earliest mirror introduced into France. It is said that it was in this room that Louis XIII. was born. On page 6 is a doorway with the arms of Louis XIII., although the general style is that of Louis XIV. This room is called the Salle du Trône, and it contains the throne of Napoleon I. Illustrations of the Empire style will be found at the end of this book.

The door in the grand vestibule at the Palais de Fontainebleau, illustrated on page 7, has the usual cartouches so representative of Louis XIII. style, and has also some other good details—for instance, the crown of thorns on the cross in the centre of door, which is a very happy idea. Some other carvings in the Louis XIII. style can be seen in the chapel at Fontainebleau, especially the side screens. The frieze round the chapel is composed of swags of fruits and flowers with the addition of cartouches, all very representative of this style. In the fireplaces of Barbet I have not shown the firebacks usual at this period. They generally bore coats-of-arms, ciphers, or emblems, and it is said that large

(*Continued on page* 8.)

4

CABINETS.

First Half 17th Century.

Louis XIII.(?)

Louis XIII. INTERIOR AT FONTAINEBLEAU. First Half 17th Century.

Interior in the Louis XIII. Style.

Louis XIII. & Louis XIV.　　**PALAIS DE FONTAINEBLEAU.**　　First Half 17th Century.

La Salle du Trône.　　The Arms of Louis XIII.

Louis XIII. **PALAIS DE FONTAINEBLEAU.** First Half 17th Century.

Door in Grand Vestibule.

8 Louis XIII. **ABRAHAM BOSSE.** First Half 17th Century.

Interior.

numbers condemned, on this account, during the French Revolution were preserved by the simple expedient of turning their face to the wall. They were made of cast iron.

On page 4 is an illustration of a very curious cabinet from the Hotel Cluny at Paris. It is covered all over in leather, and has some gilded ornament worked on it almost as delicate as one sees on the backs of books of that period.

The chimneypieces by I. Barbet show an unmistakably Italian origin. The number of carved figures on some of them must have made them extremely costly, especially if in marble or stone, of which chimneypieces were usually made at that period. I have not been able to trace anything about Barbet, but he dedicates his book to Cardinal Richelieu (1633). The engravings are by Abraham Bosse.

Carved Oak Cabinet.

Louis XIII. **HOTEL CLUNY.** First Half 17th Century.

Cabinet Inlaid with White Metal.

Writing Table Inlaid with White Metal.

Carved Oak Cabinet.

Oak Cabinet.

10

Louis XIII. **OAK SCREEN AND TABLES.** First Half 17th Century.

Church Screen.

Oak Tables.

11

Louis XIII. I. BARBET. First Half 17th Century.

Designs for Chimneypieces.

12

I. BARBET. First Half 17th Century.

Louis XIII. Designs for Chimneypieces.

13

I. BARBET. First Half 17th Century.

Louis XIII.

Designs for Chimneypieces.

14

I. BARBET. — Louis XIII. — First Half 17th Century. — Designs for Chimneypieces.

15

I. BARBET. First Half 17th Century.

Louis XIII. Designs for Chimneypieces.

16

I. BARBET.

Louis XIII. First Half 17th Century.

Designs for Chimneypieces.

17

Henry IV. or Louis XIII. **DOORWAY AND FRAME.** Early 17th Century.

B

Henry IV. **WALNUT CABINET AND ORNAMENT.** Early 17th Century.

Carved Walnut Cabinet with Plaques of Marble.

Ornament from the
Palace of Fontainebleau.

19

Henry IV. **WALNUT CABINET.** Early 17th Century.

Ornament
from the Palace of
Fontainebleau.

Carved Walnut Cabinet, with Inlaid Pilasters, etc.

Henry IV. or Louis XIII. **DETAILS.** Early 17th Century.

Henry IV. or Louis XIII. **CARVED PANEL.** Early 17th Century.

22

Henry IV. **CABINETS.** Early 17th Century.

Henry IV. Ebony Cabinet with Inlaid Ivory Panels, etc.

Ivory Coffer.

Walnut Inlaid Cabinet (Louis XIII.).

Henry IV. **WALNUT CABINET AND ORNAMENT.** Early 17th Century.

Carved Walnut Cabinet, decorated with small Marble Panels.

Friezes from the Palace of Fontainebleau.

No. 1. No. 2.

24

Henry IV. or Louis XIII. **FRAME AND ORNAMENT.** Early 17th Century.

One of the great features about this time (Louis XIII.), both earlier and later, is the beautiful plaster work in ceilings, friezes and ornaments. They were treated in a most elaborate but somewhat heavy and ponderous style. The panels were decorated by nearly every painter of repute—in fact, painting panels, ceilings, walls, etc., seems to have been their chief employment. Italy was the country which early developed plaster work, and it was Francis I. who encouraged some of the Italian plasterers to come to France to assist him on his Palace of Fontainebleau, the Italians being noted for their "stucco" work, which is an Italian term usually

25

Louis XIII.　　　　　**IMITATION CHINESE SILKS.**　　　First Half 17th Century

Venice and Lyons Silks.

applied in Italy to a superior kind of external plastering. According to Vasari, Primaticcio " did the first stucco work ever executed in France and also the first frescoes." It was used to give the appearance of stone. Stucco chimneypieces were made, also wall decoration. These Italians were continued in their employment by succeeding French kings. The designs of this period are in a very stiff and grandiose style; the reaction against this set in from the period of the Regency right down to Louis XVI.'s time, when some of the most beautiful and delicate plaster work was produced. It appears the material itself depends a good deal on its age, and the best is ground down from pieces of white marble. The way to manufacture the best plaster was kept a secret, and was handed down from father to son, each one putting down some for the benefit of his son or grandson.

Louis XIII. **DETAILS.** First Half 17th Century.

Louis XIII. **DETAILS.** First Half 17th Century.

Henry IV. or Louis XIII. **CHAIRS.** Early 17th Century.

On page 17, is a frame to go over a chimney-piece, in oak, gilt, period of Henry IV. The best carvings of this description are often found in modern houses, where they still manage to hold their place, notwithstanding that the furniture in the room does not always correspond. As they answer a useful purpose, judges of art do not care to have them removed.

The carvings and panel on pages 20 and 21 are in walnut, a wood extensively used in cabinet work about this period that lends itself to carving, and it must be remembered that articles were almost covered with carving. It is often complained that the carvings on some of these credences, dressoirs, etc., do not all appear to belong to the same period, but this may be partly explained when it is remembered that at that time trades like cabinet-making descended from father to son, and if a credence of some beautiful design was some time in hand or it came back for additions or repairs, the carver on it was influenced by the particular phase of art that was then in vogue, and which was being continually

Louis XIII. **CHAIR IN DAMASK.** Early 17th Century.

varied by fresh influences. The frame in centre of page 24 belongs to the period of Louis XIII., and is called a "Cadre de Crucifix." The centre part, which held the crucifix, had a ground of red velvet. The reader will notice how the breaks of the top of the frame suggest the arms of the cross.

On page 25 are some designs of silks in imitation of the Chinese style, and these were made in Venice and Lyons, two cities where manufacturers adapted their looms to make these silks. There was a great demand for genuine Chinese designs; but that country not yet being freely open for trade, the genuine articles fetched large prices and were scarce; hence the imitations, which were altered somewhat, to adapt them to our western ideas, in which gold was extensively used.

The three chairs on page 28 are high back chairs in walnut. The two first have cane backs, but the third has a back of Cordova leather picked out in different colours; loose cushions were probably used with these chairs. Nos. 1 and 3 are of Italian origin and design. The corner chair was a fashionable article in rooms of this period. This one is made in oak and has a wooden seat. The chair illustrated on this page is carved and gilt; it has the broad gilt braid on the edges of the stuffing, which gives a panelled effect to the appearance of the damask seat and back of the chair. This was a great feature later on during the Louis XIV. period. It has also the fringe and brass buttons common to that period, as well as the carved under-framing.

Henry IV. or Louis XIII. **CHAIRS.** First Half 17th Century.

Oak Chairs, covered in Leather, with Brass Nails.

Louis XIII. **CHAIRS.** First Half 17th Century.

Chairs, with Embossed Leather Seats and Backs and large Brass Nails, of a Portuguese design.

32
Louis XIII. **POUSSIN.** Early 17th Century.

Decorative Painting.

Louis XIV. ## CHARLES LE BRUN. Second Half 17th Century

Mural Decoration. Mercury and Peace. Versailles (about 1670).

34
Louis XIV. **PAUL MIGNARD.** Last Half 17th Century.

Louis XIV. **PAUL MIGNARD.** Last Half 17th Century.

Louis XIV. **CHARLES LE BRUN.** Second Half 17th Century.

Gobelins Tapestry by Le Brun.

Marble Fountain at Versailles.

On this page is an illustration of a marble fountain at Versailles, designed by Mansart. It is sometimes called the "Buffet" and sometimes the "Cascade," and is an example of the extended use of marble that came into vogue during the reign of Louis XIV. Old French marble quarries, closed since the Roman times, were reopened, and purchases were also made in Italy, Egypt, etc., etc., this being made somewhat easy on account of the improved means of carriage. Before this period, when marbles were used, the juxtaposition of black and white, or rather slate and white, was relied on for giving the desired effect. On the next page is a beautiful staircase in marble, also at Versailles, built about 1682.

37.

Louis XIV. **CHARLES LE BRUN.** Second Half 17th Century.

Gobelins Tapestry by Le Brun.

Marble Staircase at Versailles.

Louis XIV. **INTERIORS.** Last Half 17th Century.

Interior at Versailles.

Salle de l'Œil de Bœuf.

On this page is an illustration of the famous room called Salle de l'Œil de Bœuf, or the Ox-eye Room, so called from the oval window in the frieze. This room is mentioned in Carlyle's "French Revolution." The subject of the frieze is a "Children's Hunt," and is supposed to be one of the most beautiful specimens of Louis XIV. decorative work. It is in gilded stucco, and is by Van Cleve and others. The terrace vases, two of which are shown on page 39, are a great feature at Versailles, many of them being beautifully designed. They were executed at various times, so do not all belong to one reign. The bronze groups in Fountain Garden are claimed to be the finest in the world.

Louis XIV. **CARVINGS and VASES.** Last Half 17th Century.

Louis XIV. Carving.

Vase at Versailles.

Louis XIV. Carving.

Vase at Versailles.

Louis XIV. LOUIS XIV. SALON AT THE "LOUVRE." Last Half 17th Century.

Louis XIV. LOUIS XIV.'s BEDROOM at VERSAILLES. Last Half 17th Century.

42

Louis XIV. **DAMASK.** Middle 18th Century.

Pomegranate Pattern.

Louis XIV.　　　　　　　　**VELVETS.**　　　　　　　Middle 18th Century.

Vase Patterns.

Vase Pattern.

Velvet is usually made of rich silk, with a close, soft, fine shag or nap; but sometimes it is made of cotton or wool. The oldest makes of velvets were quite plain, but there were many other makes known by different names, among them the "Stamped or Cut Velvet," which is a velvet passed between two rollers —one of wood, holding a sizing; the other of brass, which cut and formed the design. By this means the velvet received a pattern of scrolls and flowers. There were also the Genoa velvets, Utrecht velvets, velvets in four or five colours, cotton velvets, printed velvets, embroidered velvets, and many others.

Louis XIV. **CHARLES LE BRUN (VERSAILLES).** Last Half 17th Century.

Louis XIV. GALERIE DES GLACES, VERSAILLES. Last Half 17th Century.

46

Louis XIV. **NICHOLAS LOIR.** Last Half 17th Century.

Designs for Centre Ornaments.

Louis XIV. **D'AVILIER.** Last Half 17th Century.

Designs for Balconies.

Louis XIV. **D'AVILIER.** Last Half 17th Century.

Designs for Pavements and Coves of Ceilings.

Louis XIV. **JEAN LE PAUTRE.** Last Half 17th Century

Designs for Friezes.

Louis XIV. **JEAN LE PAUTRE.** Last Half 17th Century.

Designs for Friezes.

51

Louis XIV. **JEAN LE PAUTRE.** Last Half 17th Century.

Design for Ceiling.

52
Louis XIV. **JEAN LE PAUTRE.** Last Half 17th Century.

Designs for Ceilings.

Louis XIV. **JEAN LE PAUTRE.** Last Half 17th Century.

Designs for Friezes.

Louis XIV. **JEAN LE PAUTRE.** Last Half 17th Century.

Designs for Doorways.

Louis XIV. **JEAN LE PAUTRE.** Last Half 17th Century.

Designs for Doorways.

Louis XIV. **JEAN LE PAUTRE.** Last Half 17th Century.

Designs for Chimneypieces.

Louis XIV. **JEAN LE PAUTRE and CARVINGS.** Last Half 17th Century.

Designs for Chimneypieces.

Carvings.

Louis XIV. **JEAN LE PAUTRE.** Last Half 17th Century.

Design for Chimneypiece.

Louis XIV. **JEAN LE PAUTRE.** Last Half 17th Century.

Designs for Chimneypieces.

Louis XIV. **JEAN LE PAUTRE.** Last Half 17th Century.

Designs for Chimneypieces.

Louis XIV. **JEAN LE PAUTRE.** Last Half 17th Century.

Designs for Sides of Rooms.

62
Louis XIV. **JEAN LE PAUTRE.** Last Half 17th Century.

Designs for Chimneypieces.

Louis XIV. **JEAN LE PAUTRE.** Last Half 17th Century.

Designs for Chimneypieces.

64
Louis XIV. **JEAN LE PAUTRE.** Last Half 17th Century.

Designs for Cabinets.

Louis XIV. **JEAN LE PAUTRE.** Last Half 17th Century.

No. 1. No. 2. No. 3.

Designs for Side Tables, Carved and Gilt.

Design for a Sideboard, for display of Silver.

Louis XIV. **JEAN LE PAUTRE.** Last Half 17th Century.

No. 1. No. 2. No. 3. No. 4.
Designs for Chimneypieces and Fire Backs.

Louis XIV. **JEAN LE PAUTRE.** Last Half 17th Century.

Design for Chimneypiece.

Louis XIV. **JEAN LE PAUTRE.** Last Half 17th Century.

No. 1.　No. 2.　No. 3.　No. 4.　No. 5.　No. 6.
Designs for Chimneypieces, Fire Dogs, and Fire Backs.

Louis XIV. **JEAN LE PAUTRE.** Last Half 17th Century.

Design for Chimneypiece and Fire Dogs.

70 Louis XIV. **JEAN LE PAUTRE.** Last Half 17th Century.

Designs for Doors, etc.

Louis XIV. **JEAN LE PAUTRE.** Last Half 17th Century. 71

Designs for Ceilings.

Louis XIV. **JEAN LE PAUTRE.** Last Half 17th Century.

Designs for Sides of Rooms.

Louis XIV. **JEAN LE PAUTRE.** Last Half 17th Century.

Readers will notice that each page is numbered separately, so that the number of the article and the page must both be quoted where necessary.

Designs for Sides of Rooms.

74 Louis XIV. **JEAN LE PAUTRE.** Last Half 17th Century.

No. 1.

No. 2.
Designs for Sides of Rooms.

Louis XIV. **JEAN LE PAUTRE.** Last Half 17th Century 75

No. 1. No. 2. No. 3. No. 4. No. 5. No. 6.
Designs for Pedestals, Console Tables, and Mirrors.

Louis XIV. **JEAN LE PAUTRE.** Last Half 17th Century.

Designs for Cabinets.

Louis XIV. **JEAN LE PAUTRE.** Last Half 17th Century.

77

Designs for Console Tables, Mirrors, and Pedestal.

No. 1. No. 2. No. 3. No. 4. No. 5.

Louis XIV. JEAN LE PAUTRE. Last Half 17th Century.

No. 1. No. 2.

No. 3. No. 4.

Designs for Ceilings.

Louis XIV. **JEAN LE PAUTRE.** Last Half 17th Century.

No. 1.

No. 2.
Designs for Ceilings.

Louis XIV.　　　　　**JEAN LE PAUTRE.**　　　　Last Half 17th Century.

No. 1.

No. 2.

No. 3.

No. 4.

Designs for Ceilings.

81

Louis XIV. **JEAN LE PAUTRE.** Last Half 17th Century.

No. 1. No. 2.

No. 3.

Designs for Ceilings.

Louis XIV. **JEAN LE PAUTRE.** Last Half 17th Century.

Side of Room.

Jean Berain (the father) was born in Paris about 1638. He was appointed by Louis XIV. designer to the chamber and cabinet of the King, in which capacity it was his duty to design the scenery and costumes for the court fêtes and ballets. Other architects who afterwards held this position had to do the like. It will be remembered that Inigo Jones, architect to James I., designed the scenery for the court fêtes, while Ben Jonson wrote the words. Berain died in 1711.

Jean Berain (the son) succeeded to his father as draughtsman to the King. He etched several plates from his own designs of the ornaments of panels and sculpture which are in the Gallery of Apollo in the Louvre. Bouille carried out some of Berain's designs in the panels of his cabinets, etc.

As Jean Berain was one of the artists who designed for Boule, I have thought it best to give here a description

(*Continued on page 87.*)

Louis XIV. **JEAN LE PAUTRE.** Last Half 17th Century. 83

Designs for Cornice Ornaments.

Design for Ceiling.

Louis XIV. **JEAN LE PAUTRE.** Last Half 17th Century.

No. 1.

No. 2.

No. 3.

Designs for Friezes.

Louis XIV. **JEAN LE PAUTRE.** Last Half 17th Century.

Nos. 1 and 2.

Nos. 3 and 4.
Designs for Friezes.

86 Louis XIV. **JEAN LE PAUTRE.** Last Half 17th Century.

Designs for Ceiling Ornaments.

Louis XIV. **JEAN LE PAUTRE.** Last Half 17th Century.

Design for Chimneypiece, etc.

of what constitutes "Boule" work—instead of under the name of Boule.

"Boule itself is a peculiar kind of inlaid or veneered work composed of tortoiseshell and thin brass, to which other metals, enamel, and ivory are sometimes added. Even in the first works of Andre Charles Boule the great capabilities of his new style were well understood, and fully carried out. The play of light upon the surface and the variety of curvature commonly found in different parts of the piece of furniture are admirably adapted to show off to advantage the rich materials employed. From whatever position we may look at good examples of this and of the succeeding period we find a brilliant and lustrous effect produced upon the polished metal; whilst the mingling of silver, brass, tortoiseshell, ivory, and enamel, supplies additional and beautiful tones of colour.

"In the earlier furniture made by Boule the inlay was produced at great cost, owing to the waste of material in cutting; and the shell is left of its natural colour. In later work the manufacture was more economical. Two or

(*Continued on page* 109.)

Louis XIV. **JEAN LE PAUTRE.** Last Half 17th Century.

Design for Frieze.

Design for Side of Room.

Design for Frieze.

89

Louis XIV. **PIERRE LE PAUTRE.** Last Half 17th Century.

Designs for Chimneypieces.

Design for Arabesque Ornament.

Louis XIV.　　　**JEAN BERAIN.**　Last Half 17th Century and Early 18th Century.

Designs for Pilasters.

Louis XIV. **JEAN BERAIN.** Last Half 17th Century and Early 18th Century.

Designs for Pilasters.

Louis XIV. **JEAN BERAIN.** Last Half 17th Century and Early 18th Century.

Designs for Pilasters.

Louis XIV. **JEAN BERAIN.** Last Half 17th Century and Early 18th Century.

Designs for Pilasters.

Louis XIV. **JEAN BERAIN.** Last Half 17th Century and Early 18th Century.

Design for Panel.

Louis XIV.　　　**JEAN BERAIN.**　Last Half 17th Century and Early 18th Century.

Design for Panel.

Louis XIV. **JEAN BERAIN.** Last Half 17th Century and Early 18th Century.

Design for Panel.

Louis XIV. **JEAN BERAIN.** Last Half 17th Century and Early 18th Century.

Designs for Panels.

Louis XIV. **JEAN BERAIN.** Last Half 17th Century and Early 18th Century.

Design for Panel.

Louis XIV. **JEAN BERAIN.** Last Half 17th Century and Early 18th Century.

Design for Panel.

Louis XIV. **JEAN BERAIN.** Last Half 17th Century and Early 18th Century.

Design for Panel.

Louis XIV. **JEAN BERAIN.** Last Half 17th Century and Early 18th Century.

Design for Panel.

Louis XIV. **JEAN BERAIN.** Last Half 17th Century and Early 18th Century.

Design for Panel.

Louis XIV. **JEAN BERAIN.** Last Half 17th Century and Early 18th Century.

Design for Panel.

104

Louis XIV. **JEAN BERAIN.** Last Half 17th Century and Early 18th Century.

Design for Panel.

Louis XIV. **JEAN BERAIN.** Last Half 17th Century and Early 18th Century.

Side View. Back View.
Design for Sedan Chair.

106
Louis XIV. **JEAN BERAIN.** Last Half 17th Century and Early 18th Century.

Design for Panel.

Louis XIV. **JEAN BERAIN.** Last Half 17th Century and Early 18th Century.

Design for Panel.

108 Louis XIV. **JEAN BERAIN.** Last Half 17th Century and Early 18th Century.

No. 1. No. 2. No. 3. No. 4. No. 5.
Designs for Tripod, Wall Decoration, Chimneypiece, &c.

Louis XIV. **JEAN BERAIN.** Last Half 17th Century and Early 18th Century. 109

No. 1. No. 2.

three thicknesses of the different materials were glued together and sawn through at one operation. An equal number of figures and of matrices or hollow pieces exactly corresponding were thus produced, and, by countercharging, two or more designs were obtained by the same sawing. These are technically known as 'boule and counter,' the brass forming the groundwork

(Continued on page 115.) No. 3. No. 4. No. 5. No. 6.

Designs for Chimneypieces and Fire Backs.

110 Louis XIV. **JEAN BERAIN.** Last Half 17th Century and Early 18th Century.

No. 1. No. 2. No. 3. No. 4. No. 5. No. 6. No. 7.

Designs for Chimneypiece Decoration and Fire Backs.

Louis XIV. **JEAN BERAIN.** Last Half 17th Century and Early 18th Century. 111

112

Louis XIV. **JEAN BERAIN.** Last Half 17th Century and Early 18th Century.

Designs for Candlesticks.

Louis XIV.　　　　　　　　**DANIEL MAROT.**　　　　Second Half 17th Century.

Fire Dogs by Jean Berain.

No. 1.　　　　　　　　No. 2.　　　　　　　　No. 3.

Designs for Backs and Panels of Sedan Chairs by Daniel Marot.

(See page 117 for description.)

114
Louis XIV. DANIEL MAROT. Second Half 17th Century.

Grandfather Clocks.

Louis XIV. **DANIEL MAROT.** Second Half 17th Century.

Grandfather Clocks.

and the pattern alternately. In the later boule the shell is laid on a gilt ground or on vermilion. Sometimes the two styles are distinguished as the first part and the second part. The general opinion on the relative value of each seems to be that, while admitting the good effect of the two styles as a whole, the first part should be held in higher estimation as being the more complete. We there see with what intelligence the elaborate graving corrects the coldness of certain outlines; the shells trace their furrows of light, the draperies of the canopies fall in cleverly disordered folds, the grotesque heads grin, the branches of foliage are lightened

Louis XIV. **DANIEL MAROT.** Second Half 17th Century.

Bracket Clocks.

by the strongly-marked edges of the lines, and everything lives and has a language. In the counterpart we can find only the reflection of the idea, and the faded shadow of the original."

Daniel Marot was born in 1650, and died about the year 1700. His style well represents the second period of Louis XIV. He was architect to William III., and his influence is distinctly noticeable in the furniture, etc., at Hampton Court Palace; the bedst ads, for instance, with their high heavy hangings, and the peculiar backs over the pillows. He also designed for Boule, and on this page and the next are some Bracket Clks that were probably made in boule ork. They have the bass unts, such as female figures, cupids, caryatides, husks, terminal feet, edgings, etc., all richly chased. The original use of these parts was to pect the edges and angles, and bind the thin inlaid work together here it was interrupted by angles in the structure. The dials in the clocks are beautifully designed, and some ther examples are shown a few pages further on. The Grandfather Cl cks were mde in oak, and have the peculiar strap-like

Louis XIV. DANIEL MAROT. Second Half 17th Century.

Bracket Clocks.

carving which is a peculiarity of the Louis XIV. style. The locks are taken from a work published by Marot at Amsterdam, and it is curious to note how far the designs may take a lead style in some of his simpler designs. On page 113 are one of this for the backs and panels of each chairs, which were probably executed in a damask. I give the a description of a contemporary sedan chair, but of a what earlier date, which may give an idea of how they were finished. The side was black morocco, relieved with gilt braid, and finished with gilt or bars dots of different size. The interior was of crimson of a damask, with a small flower for pattern, with gilt braid and a fringe above; at each side the partition was openwork, and furnished with a little stained glass window of crystal set in gilt leadwork. The bars and the side straps are covered with red cloth and a fringe. For further particulars as to the decoration of sedan chairs refer to them under their different headings. On pages 118 and 119 are designs of chimneypieces in oak, these being very

(Continued on page 122.)

118 Louis XIV. **DANIEL MAROT.** Second Half 17th Century.

Chimneypieces in Oak, with Overdoors and Overmantels painted.

No. 1. No. 2. No. 3.

Louis XIV. **DANIEL MAROT.** Second Half 17th Century. 119

No. 1.
No. 2.
Chimneypieces in Oak, with Overdoors and Overmantels painted.

120 Louis XIV. DANIEL MAROT. Second Half 17th Century.

Chimneypieces and Overmantels for the Display of China.

No. 1. No. 2.

Louis XIV. **DANIEL MAROT.** Second Half 17th Century. 121

No. 2. Chimneypiece and Overmantel.

No. 1. Corner Chimneypiece.

Louis XIV. **DANIEL MAROT.** Second Half 17th Century.

No. 1.
Chimneypiece and Overmantel.

No. 2.
Ornament suitable for Pilasters.

similar to those to be seen at Hampton Court Palace. They have the heavy moulding round the open fireplace, which was frequently of marble, the small piece of glass, and the carved Acanthus-like leaf in the moulding above it, which was often surrounded by strapwork and has a pleasing effect. In the present examples the upper part has the painted panel with vases and flowers after the Dutch style, and the upper mouldings continuing the cornice of the room. Among other features are the low dado and the fire-backs. These last were cast, and usually bore coats-of-arms, ciphers, or subjects emblematic of heathen

Louis XIV DANIEL MAROT. Second Half 17th Century.

No. 1.
Ornament suitable for
Pilasters.

No. 2.
Chimneypiece in the "China" taste.

mythology, etc. On page 120 are some overmantels for the display of china (Delft), quite a rage for which existed about this time. On page 121 is a corner fireplace which will recall a small room at Hampton Court Palace. Above is shown a chimneypiece in the "China" taste, which helps to show to what a gross absurdity the Delft chinaware craze was carried—cups and saucers everywhere. No. 1 was probably executed in oak, enriched with gilding, but in low relief. On pages 124 and 125 are overdoors which had paintings in them. On pages 126 and 127 are designs which could be either painted or executed in tapestry.

124
Louis XIV. **DANIEL MAROT.** Second Half 17th Century.

Three Designs for Overdoors, the top one suitable for Double Door.

Four Designs for Overdoors.

125

Louis XIV. **DANIEL MAROT.** Second Half 17th Century.

Two Designs for Overdoors and one Design for Panel over Chimneypiece.

Two Designs for Overdoors and one Design for Panel over Chimneypiece.

126
Louis XIV. **DANIEL MAROT.** Second Half 17th Century.

Designs for Panels.

Louis XIV. **DANIEL MAROT.** Second Half 17th Century.

Designs for Panels, emblematic of the Air and the Earth.

128 Louis XIV. **DANIEL MAROT.** Second Half 17th Century.

Table Top. Table Top.

The Ceilings of Beds, made in Galon (a close lace of silk, gold or silver).

129

Louis XIV. **DANIEL MAROT.** Second Half 17th Century.

Designs for Chantournés. Design for Pilaster.

Above are three designs for what the French call Chantournés, the head pieces placed over the pillows against the wall, some of which can be seen at Hampton Court Palace. Some further examples are given in the illustrations of bedsteads two pages further on. They were made of carved wood and gilt, or of plain wood and covered either with cloth, the latter sometimes embroidered, with blue taffeta, with white satin pique, or, as in the three designs here represented, with galon, a close lace made of silk, gold, or silver. The term galon, however, is applied to a variety of similar materials.

Louis XIV. **DANIEL MAROT.** Second Half 17th Century.

Designs for Bed Valances.

Four illustrations of what the French call Lambrequins are given here. These are the hanging bands of materials which are used to decorate the tops of windows and the tops of bedsteads. The third example is called a Lambrequin galonné, on account of the banding. Galon was a general term for the many closely woven materials made by the trimmings manufacturer, among others glossy serge, epinglés galon, and galon of gold and silver. The fourth design is called Lambrequin à falbalas, from the folding of the drapery at the bottom of the valance.

Daniel Marot seems to have been rather happy in his designs of this class of work. The four designs here shown and the four designs round the tops of the bedsteads on the next page show great variety, and are quite worthy to be compared with our modern designs of such subjects. The French have a great variety of bedsteads, and draw very fine distinctions between the different designs, giving each a name. In fact, they have paid extra attention to this piece of furniture, no doubt remembering that it is in it " we forget, during one part of our life, the evils of the other part "; further, that " in it we are born, and in it we die." Before the end of the 16th century the bedsteads in use were of a somewhat primitive type, but about that time luxury began to creep into the homes, and the bedstead was among the first articles to be affected. Under the name of Abraham Bosse in the earlier part of this work will be found an illustration of a form of bedstead which seems to have been the fashion during the earlier part of the 17th century. The hangings there shown were often very rich, and I have there described them. On the tops of Nos. 1, 2 and 4 bedsteads on page 131 are shown what the French call the Bouquet de Plumes, a bunch of feathers. This ornament was in use during the 16th and 17th centuries, and was supposed to add to the dignity of the design. Examples can be seen on the bed of Louis XIV. at Versailles, also on a bed at Hampton Court Palace, at Knole Park, etc. The feathers were of different colours, green, yellow, white, etc., and of various sizes, large, medium, and small, mixed together, with the addition of aigrettes. The cases on which they were placed were occasionally of cardboard covered with embroidered velvet. These bouquets were sometimes made of flowers cut out of the precious metals. The coverings of beds during the 17th century, especially during the latter half, were of a marvellous richness and variety, and comprised all manner of stuffs—Genoa and Bruges damask, cloths of gold and silver, striped gauzes, striped satins, muslins, velvets, and damasks of all colours, white, crimson, yellow, green, violet, black, grey, etc., etc., French and Oriental satins, taffetas, brocades, tapestries, and many other materials, all of which were decorated or embroidered with lace or with trimmings of gold and silver or

(Continued on page 135.)

Louis XIV. **DANIEL MAROT.** Second Half 17th Century. 131

No. 1. No. 2.

No. 3. Designs for Bedsteads. No. 4.

Louis XIV. DANIEL MAROT. Second Half 17th Century.

Designs for Brackets, Console Table, and Centre Table.

Designs for Lamp Stands, Girandole, Console Tables, and Mirror.

Louis XIV. **DANIEL MAROT.** Second Half 17th Century.

Designs for Sconces and Mirrors.

Designs for Brackets and Girandoles.

134

Louis XIV. **DANIEL MAROT.** Second Half 17th Century.

Designs for Teapots, Milk Jugs, Vases, Urns, etc.

Designs for Candelabra.

Louis XIV. **DANIEL MAROT.** Second Half 17th Century.

needlework, some with subjects, others with flowing ornament or with armorial bearings. The four pillars of the beds were often covered with the same materials as the bed ; sometimes with silver sheet. A great many of these coverings were lined with some other material. The fringes were also an important feature. It was the custom in those days for people to receive their friends in bed (as described under Abraham Bosse in an earlier part of this book), and for the kings and other great personages to give audience while in bed, and this, no doubt, was one of the causes that led the bedstead to be treated so sumptuously. Some of the best bedsteads cost almost fabulous sums. The following are a few of the more important bedsteads that were in use about this time. There was the Lit à Alcôve, which was a bedstead placed in an alcove so that it was separated from the rest of the room. In some instances it was on a platform with balustrades in front between two pillars. Part of the balustrade would have a sort of gate so that one could enter the alcove, but in this latter case it was called a Lit de Parade, an illustration of which can be seen

Designs for Garden Vases.

further on in this book in the interior of Louis XIV.'s bedroom. These alcove beds are still in vogue in France, and by drawing a panelling or curtain in front they are really separated from the rest of the room. The Lit d'Ange is a bedstead with a canopy, but with no pillars in front, the curtains being drawn back at the sides next to the head of the bed. The canopy does not extend over the whole of the bedstead, but the counterpane goes right over the foot. Lit de Bout is a bed, the pillow of which only touches the wall, the other sides remaining free. Readers will notice that the canopies of beds were a great feature during the 17th century, covering the whole of the bed. During the 18th century, however—perhaps through the chimneypieces not being so open, and the windows and doors being better fitted, and a consequent lessening of draught—there was no longer the necessity for wholly enclosing the beds with canopy and curtains as they did in the earlier times, so the canopy gradually grew less, and the curtains were placed at the pillow end of the bed.

Louis XIV. **DANIEL MAROT.** Second Half 17th Century.

Designs for Cornice Mouldings.

Designs for Picture Frame Mouldings.

Lit Clos is a bed placed in a sort of cupboard with sliding doors.

Lit à Colonnes, à Quenoulles, à Piliers are terms for four-posted bedsteads. The posts are exposed when they are carved, etc., and in other cases they are hidden by the curtain.

Lit en Dome is a bed that has a rounded canopy over it in the shape of a dome, sometimes confounded with Lit à Impériale, which has a dome suggestive of an Imperial Crown.

Lit de Garderobe, a bed used by the servants waiting on the king and queen, and placed in rooms adjoining the royal bedrooms, called Garderobes. They were somewhat of a square tent shape, and could easily be put up or taken down.

Lit de Glacé is a bed with a mirror placed in the back. The mirror was afterwards framed in the ceiling of the bed.

Lit à Impériale had a sort of ogee canopy. This bed seems to have been in fashion for a considerable period, from the 16th to the end of the 18th centuries.

Louis XIV. **DANIEL MAROT.** Second Half 17th Century.

Lit de Parade was a bed placed in the chief bedroom, and could only have been used by royalty or members of the highest nobility—a state bed. I have given an illustration of Louis XIV.'s bedroom at Versailles on page 41. It was his bedroom from the year 1701 until he died in it in 1715. Here it was that the great audiences were held, and here he received the remonstrances of his Parliament; here also he dined "au petit couvert," virtually privately, as distinguished from when he dined "au grand couvert," when spectators were freely admitted. And after his death, on this bed his body lay in state, when the people were admitted to view his remains. The origin of the custom of showing the body of the king or chief after his demise is lost in obscurity, but no doubt in barbarous times it was to satisfy the people that their ruler was no more. The illustration given must not be taken as typical of a Lit de Parade, as of course the design varied with the time. Further, the term is applied as much to the balustrade in front and the raised platform as to the bed itself.

Lit en Tombeau was a bed in common use during the 17th century. It had a canopy carried on four pillars. The two pillars at the bottom of the bed were shorter than those at the pillow end, consequently the canopy or ceiling of the bed sloped towards the foot. There were curtains on both sides which could be let down, thus enclosing the whole of the bed. An improvement on this was the Lit en double Tombeau, which had a small dome over the centre of the bed and four curtains, two

Designs for Ceilings.

138

Louis XIV. **DANIEL MAROT.** Second Half 17th Century.

Designs for Watch Fronts and Backs, Watch Hands, Snuff Boxes, etc.

Designs for Backs of Watches, Keys, Watch Seals, etc.

Louis XIV. **DANIEL MAROT.** Second Half 17th Century.

on each side, with a fixed piece of material from the canopy going over the head and foot of the bed.

Lit Tournant, see No. 2, page 131. Readers will remember that the beds in the olden time were enclosed with curtains all round, but other designs for beds of a more open character were coming into fashion; for example, Lit d'Ange, described on page 135. In these beds people found themselves liable to be caught unawares. This is a French idea, but, at the same time, it must be remembered the bedroom in those days in France was not strictly confined to sleeping purposes, but was used as a sitting room as well. To get

Design for Coach for William III.

over this difficulty, and yet show the beautiful design of the bedstead, the valances, the chantournés, etc., etc., an iron curtain rod round the top of the bedstead was adopted, along which it was possible to draw very light silk curtains from each side, and yet in the day, when the bed, as it were, was "on show" the curtains could be drawn back to the sides.

On page 132 is a design for a console table which was probably carved and gilt. The mirror above it reminds one of its Italian origin. The lamp stands and the rest of the articles would be also carved and gilt. All the articles illustrated on page 133 were also probably carved and gilt. On page 134 some candelabra are shown, known as lustres by the French. They were made in wood, carved and gilt, in silver, silver gilt, or in brass work richly chased. The designs for urns, which in those days were really large water jugs, were sometimes of a most ornate character, some of them being in silver gilt, richly chased. During Louis XV.'s time some were made of porcelain with bronze mounts, richly chased and gilt. On page 135 are shown vases or flower pots of sufficient size to take small orange trees, etc. These were sometimes of silver and placed in the larger apartments. Thus we read that there were some in silver, fashioned by the most skilful workmen, in the famous glass gallery at Versailles, which vases Louis XIV., when pressed for money, ordered to be melted down and made into coin. The taste for these vases, urns, etc., was brought about by the fashion set by Louis XIV. and his court of having rare plants and flowers to decorate the interiors of their mansions and also their gardens, the laying out of which at that time had developed into a fine art. Some of these garden vases in stone or marble are of the highest form of art. On page 136 are some designs for cornice mouldings, etc. Readers will admit they are well designed, and we quickly recognise them as belonging to the reign of Louis XIV. There are mouldings of this class to be seen on the woodwork in the State apartments of

Louis XIV. ANDRÉ CHARLES BOULE. Second Half 17th Century.

Hampton Court Palace. Readers will remember that Daniel Marot was architect to William III., who had these rooms built.

On page 137 are some designs for ceilings. During the 17th century the decoration of ceilings was carried to a degree of extravagance hitherto unknown, nearly all the artists of note of that period designing them. The cost of some of these designs must have been fabulous. The subjects were in most cases based on the Roman mythology. The ceilings painted by Le Brun, assisted by other artists, at Versailles, are good examples of this style of painting. I have illustrated a portion of one by Le Brun, on page 44. Charles II. and William III. had some ceilings painted in this style by Verrio and Laquerre at Hampton Court Palace, Windsor Castle, etc. The style of these ceilings originated in Italy, and the compo or plaster work appertaining to them was carried out by Italians who worked at Versailles and at the Louvre, etc., for a number of years. In some of these designs there is an optical delusion gained by false shading, imitating reliefs. The plaster work is set off with an enormous amount of gilding, and the subjects of the paintings, etc., if not treating of Roman or semi-Roman mythology, were of a warlike semi-heroic character. Such a one is to be seen in the centre compartment of the Galerie des Glacés at Versailles called " Louis XIV. Governing by Himself."

On page 138 will be found designs for watch cases, etc. These patterns are suitable for enamelling or for niello work, a kind of black enamel. They could be simply engraved and treated as watches are now in

141

Louis XIV. **ANDRÉ CHARLES BOULE.** Second Half 17th Century.

two or more shades of gold or silver. The three centre boxes are what the French call "Bonbonnière," or sugar plum boxes.

On page 139 is an illustration of a coach designed for William III. in 1698 by Daniel Marot. The ground is gold, the panels, etc., painted, the carved ornaments gilt.

On page 140 some of Boule's cabinet work is illustrated. The first bracket clock is in the Victoria and Albert Museum, London. The second one, also standing on a plinth, has the brass inlaid on black shell, enriched with numerous

142 Louis XIV. **ANDRÉ CHARLES BOULE.** Second Half 17th Century.

Candelabra.

Louis XIV. **ANDRÉ CHARLES BOULE.** Second Half 17th Century.

bronzes, carved and gilt. The consoles and festoons on doorposts are in projection; the grotesque head is crowned with roses, vases with flames issuing forth are on the cornices, and the figure of Fame is on the top of dome. The centre monumental clock is decorated with marqueterie of metal on tortoiseshell. The mounts and ornaments are of gilt bronze cast and chased. The main motive of the clock is "Love and Time."

On page 141 is a boule cabinet with shaped sides and marble top and very fine brass mounts; the other is from the Louvre, and has metal on tortoiseshell. The barometer and thermometer has the boule marqueterie of brass and metal on a ground of red tortoiseshell with gilt bronzes. There is a statuette of a child in the Chinese style on top of the frame, and a grotesque head blowing.

On page 142 are some designs of what the French call Girandoles, which are candle stands to hold several lights. Those hanging from the ceiling are called Lustres. There are also some called Bras Applique, Bras de Cheminée—bras meaning an arm. These were placed on the wall wherever they were wanted.

A brass chandelier or lustre with branches and nozzles for eight lights by Boule is illustrated on this page. This lustre was originally in "Le Chateau de Caderousse."

Candelabrum.

Candelabrum.

144

Louis XIV. **ANDRÉ CHARLES BOULE.** Second Half 17th Century.

Another lustre or chandelier by Boule is illustrated on page 143. This is in the Jones Collection. It is in chased ormolu, with branches and nozzles for eight lights.

A Bras Applique in chased bronze and gilt is shown here. The cabinet below is by Boule. The brass marqueterie is on black tortoiseshell, of a very rich and varied design. Two grotesque heads in brass, crowned with palms, decorate the sides, and it will be noticed there are two locks to each door.

André Charles Boule was born in 1642. On page 87 will be found a description of boule work. It is made in various ways—

Candelabrum or Bras Applique.

tortoiseshell on brass or white or yellow metal, and brass or metal on tortoiseshell. Sometimes marqueterie (wood) is added to the designs in colours, also in ivory and copper. Of course, in boule work, much depends on the brass or gilt bronze mounts, which were cast in the first case and then chased. There are instances of this class of metal inlay before the time of Boule, but not the combination of metal and tortoiseshell. Sometimes silver mounts were used. This class of work exerted an immense influence in Louis XIV.'s time—Boule being Director of the Works at Versailles. From a description of a fire which occurred on his premises we get some insight into the scale on which he carried on his business, which must have been very large, as he employed joiners, cabinet-makers, carvers, bronzers, chisellers, mounters, polishers, marqueterie cutters, and a host of others.

Boule also kept an immense stock of finished and unfinished work, besides the collection he had gathered together as a connoisseur—drawings by Raphael, models in wax, medals, prints, and all sorts of works of art—which he and

Boule Cabinet.

(*Continued on page* 150.)

Louis XIV. **GALERIE D'APOLLON (LOUVRE).** Last Half 17th Century.

146
Louis XIV. **ANDRÉ CHARLES BOULE.** Second Half 17th Century.

Boule Clock.

Boule Writing Tables.

Louis XIV. **ANDRÉ CHARLES BOULE.** Second Half 17th Century.

Boule Clock.

Boule Writing Tables.

Louis XIV. **ANDRÉ CHARLES BOULE.** Second Half 17th Century.

Boule Commode.

Boule Cabinet.

Boule Clock.

Louis XIV. **ANDRÉ CHARLES BOULE.** Second Half 17th Century.

Boule Cabinet.

Boule Clock.

Boule Cabinet with Marqueterie Panels.

Boule Cabinet with Marble Top.

Louis XIV. ANDRÉ CHARLES BOULE. Second Half 17th Century.

Boule Cabinet.

Gilt Console Table.

Boule Cabinet.

his assistants consulted in the course of their studies. He got into low water towards the end of his life, and was engaged in numerous law suits. There is no doubt that his work was of the highest excellence. Both Berain and Marot designed ornaments for him, as already mentioned. On page 145 is a reproduction of the Galerie d'Apollon at the Louvre, Paris. This salon, which is over 200 feet long, was begun from the designs of Charles Le Brun, who, however, left the decoration unfinished. I have shown it here as the furniture, which is mostly boule, belongs to the time of Louis XIV. The decoration of this gallery was not completed until the years 1848-51. Several of the paintings in the ceiling are by Le Brun —Apollo (which represents the Sun), Morpheus or Evening, Night or Diana and the Triumph of the Waters (Neptune and Amphitrite). . The other paintings in the ceilings are comparatively modern. The panels of the

151

Louis XIV. **ANDRE CHARLES BOULE.** Second Half 17th Century.

walls are adorned with portraits of twenty-eight French kings and artists in modern Gobelins tapestry. The surrounds of some of the frame work, instead of being in marble, as they would have been in Louis XIV.'s time, are merely imitation, which seems rather paltry, especially as this gallery is described as one of the finest in Europe. On pages 146 and 147 are three writing tables with the designs of the marqueterie after the style of Berain. They

Console Table.

Gilt Screen.

Boule Centre Table.

Boule Side Table.

152
Louis XIV. **ANDRÉ CHARLES. BOULE.** Second Half 17th Century.

Boule Cabinets.

Gilt Console Table.

Louis XIV. **ANDRÉ CHARLES BOULE.** Second Half 17th Century.

often had humorous subjects called "singeries," composed of monkeys on swings, etc., which style was in vogue during the earlier part of the 18th century. The decoration was occasionally varied with ivory, mother of pearl, and other coloured materials on the metal. The upright clocks are in the usual style of this period, the clock being separate and placed on a pedestal. On some of these cabinets are designs of brass figures in relief. Hungerford Pollen says anent this :—" Besides these plates of brass for marquetry ornaments, Boule, who was a sculptor of no mean pretensions, founded and chased up feet, edgings, bracket supports, etc., to his work in relief, or in the round, also in brass. The original use of these parts was to protect the

(Continued on page 161.)

Gilt Clock on Table.

Gilt Metal Clock.

Boule Marriage Caskets.

Louis XIV. **CARVINGS.** Last Half 17th Century.

Louis XIV Carved Panel.

Boule Clock.

Louis XIV. Carved Panel.

155

Loui XIV. **J. FRANCART.** (?) Last Half 17th Century.

Designs for Doors.

156
Louis XIV. J. FRANCART. (?) Last Half 17th Century.

Designs for Doors.

Louis XIV.　　　　　　　**J. FRANCART. (?)**　　　　Last Half 17th Century.

Designs for Doors.

158
Louis XIV. **J. FRANCART. (?)** Last Hall 17th Century.

Designs for Doors.

Louis XIV. **J. FRANCART. (?)** Last Half 17th Century.

Designs for Doors.

160

Louis XIV. J. FRANCART. (?) Last Half 17th Century.

Designs for Doors.

Louis XIV. **WALLACE COLLECTION, ETC.** Late 17th Century.

edges and angles, and bind the thin inlaid work together where it was interrupted by angles in the structure. Afterwards brass mounts, more or less relieved, were added to enrich the flat designs of the surfaces. Classical altars, engraved or chased as mere surface decoration, would receive the addition of claw feet actually relieved. Figures standing on such altars, pedestals, etc., were made in relief more or less bold. In this way Boule's later work is not only a brilliant and rich piece of surface decoration, but its metallic parts are repoussé or embossed with thicknesses of metal ornament. In boule work all parts of the marquetry are held down by glue to the bed, usually of oak. The metal is occasionally fastened down by small brass pins or nails, which are hammered flat and chased over so as to be imperceptible."

Louis XIV. Cabinet.

Louis XIV. Chair.

Louis XIV. **GUÉRIDONS AND ORNAMENT.** Late 17th Century.

Carved and Gilt Guéridons.

Louis XIV. Frieze.

163

Louis XIV. **TABLES AND ORNAMENT.** Late 17th Century.

Carved and Gilt Tables.

Louis XIV. Frieze.

Louis XIV. Ornament.

Louis XIV. **WALLACE COLLECTION.** Last Half 17th Century.

Group at the Wallace Collection.

On page 161 is a monumental clock and pedestal of ebony, with a decoration in marqueterie of metal on tortoiseshell, the framework, reliefs, and ornaments being of gilt bronze, cast and chased. The clock is by Mynuël, and came from the atelier of Boule. Its supports are terminal figures of fantastically-costumed warriors with their accoutrements. On the summit is a statuette of Cupid shooting. The circular bas-relief on the pedestal shows Hercules relieving Atlas of the burden of the globe. On the same page to the right is a cabinet with two doors in marqueterie of rosewood and satinwood, the doors formed of two remarkable lacquer panels in relief—Chinese figures, men on horseback and on foot hunting, engraved and tinted; also having some parts of mother-of-pearl.

Above is shown a table of ebony and gilt metal, covered with marqueterie in tortoiseshell, copper, and white metal on yellow metal. This table is also by Boule, of late style and period of Louis Quatorze. The fanciful design, including many grotesque figures akin to those of Italian comedy, recalls that which originated with Bérain, but is not of such quality as to be attributable to him. On the above table is a mirror in marqueterie of metal on tortoiseshell, with mounts of gilt bronze, cast and chased. The style shown in the fanciful grotesques and arabesques with which the framework and back of the mirror are

Louis XIV. **WALLACE COLLECTION, ETC.** Last Half 17th Century.

Group at the Wallace Collection.

Carved and Gilt Pedestal.

covered is that of Bérain. At the back to the right in this group is a buffet shaped as a large commode in mahogany, with mounts and ornaments of gilt bronze, cast and chased. This buffet is signed J. F. Leleu, and is of the style and period of Louis Seize. The fleur-de-lys alternating in the delicately wrought frieze with foliage of classic type would appear to indicate that this piece was made for a Prince of the Royal House of France. At the back in the centre of this group is a cabinet of ebony with marqueterie of metal on tortoiseshell of the same style and period. The decorative plaques of gilt bronze, cast and chased, are from the design of Clodion. In the centre of the frieze are set reliefs in *pietra dura* of Florentine manufacture. To the left in this group is a square commode of walnut wood, with mounts and ornaments of gilt bronze, cast and chased, also of the same style and period. André Charles Boule died in 1732.

Louis XIV. **D. MAROT (INTERIORS).** Late 17th Century.

Louis XIV. D. MAROT (INTERIOR). Late 17th Century.

Interior of Library.

A great feature of French furniture are the lacquer panels, beautifully mounted with ormolu richly chased. These lacquer panels came from Japan and China, the former being the most highly esteemed both on account of their delicacy and finish and their durability. They will stand a high temperature, a very great consideration when one remembers how susceptible lacquers are to a change of climate, as many Americans have found who have imported them into the United States. There are several kinds of lacquers, for example:—Silver lacquer, the lac being mixed with silver leaf rendered liquid by means of camphor; lacquer on gold ground, the oldest and most highly esteemed; avanturine lacquer work, occasionally seen on large cabinets having bright particles all over it which seem to recede; red lacquer, which comes from Japan; black lacquer, often stippled over with gold spots. When the black lacquer is plain it is called "mirror lacquer." The process of lacquering is explained in one of the Art Handbooks of the Victoria and Albert Museum, and is usually as follows:—The wood, when smoothly planed, is covered with a sheet of thin paper or silk gauze, over which is spread a thick coating made of powdered red sandstone and buffalo's gall. This is allowed to dry, after which it is sometimes polished and rubbed with wax, sometimes covered again with a wash of gum-water holding chalk in solution. The varnish is laid on with a flat brush, and the wood is then put in a room to be very slowly dried. From thence it passes into the hands of a workman who moistens and again polishes it, generally with a piece of extremely fine-grained soft clay slate. It then receives a second coat of lacquer, and when dry is once more polished. These operations are repeated until the surface becomes perfectly smooth and lustrous. There are never less than three coatings, and seldom more than sixteen; although it is said that some old Chinese and Japan pieces have received upwards of twenty. The piece has then to be painted. The sketch is drawn with a brush dipped in white lead, and then with a graver, after which the design is finally traced with a pigment, diluted in a solution of prepared glue. The lines are done over with lac made liquid by camphor, and are then gilded. The reliefs are obtained with a thicker mixture of gum lac, and a peculiar kind, called Fo-Kien's, is used for the final touches.

A. *Portrait de sa MAJESTE BRITANIQUE GUILLAUME III et qualité de STADHOUDER*
B. *Le PRESIDENT*
C. *Le PENSIONNAIRE de Hollande*
D. *Le GREFFIER*
E. *Les AGENTS*
V. *et G. Place des AMBASSADEURS*
H. *Portrait de GUILLAUME I PRINCE D'ORANGE.*
I. *Portrait de PHILIPPE II D'ESPAGNE.*
k. *Portrait du PRINCE FREDERICK-HENRY.*

LA GRANDE SALE D'AUDIENCE DE LA HAYE, OU LES SEIGNEURS ETATS ET TIENNENT-

Cette Sale a été Construite sur les desseins de

MAROT. Late 17th or Early 18th Century.

GENERAUX DES PROVINCES-UNIES, REÇOIVENT LES AMBASSADEURS, LEURS ASSEMBLÉES.

Louis XIV. **MANSART.** Late 17th Century.

Doorways at the Grand Trianon.

171

Louis XIV. **MANSART.** Late 17th Century.

Doorways, etc., at Versailles.

Ironwork by Daniel Marot.

Louis XIV. CHIMNEYPIECES, ETC. Late 17th Century.

On page 165 is shown a monumental clock, decorated with marqueterie of metal on tortoiseshell, the mounts and ornaments of gilt bronze, cast and chased. The main motive of the clock is Love and Time. The manner is that of the Boule atelier, it is signed Thuret, and is of the style and period of Louis Quatorze. Here also may be seen a monumental pedestal of ebony, with marqueterie of metal on tortoiseshell and mounts of gilt bronze, cast and chased. The chief motives of the marqueterie are, in front, water-serpents intertwined with reeds, and, at the sides, lyres grouped with other musical instruments. It is of the same style and period. On one side is a guéridon of ebony, with marqueterie of tortoiseshell on white metal and yellow metal, and mounts of gilt bronze, also of the same style and period. There is a companion guéridon on the other side. On these guéridons are placed two candlesticks (*flambeaux*) of gilt bronze, the stems formed by decorative figures, in the one case of a woman and boy, in the other of a man and boy. These are late Louis Quatorze style and period.

173

Louis XIV. **CHIMNEYPIECES, ETC.** Late 17th Century.

 Many of the illustrations in this book have been copied by permission of the Trustees from the Wallace Collection, which is peculiarly rich in examples of the style of the Louis XIV. period among others. I have ventured to copy some parts of the "Introduction" to the Catalogue of the Wallace Collection.

 This glorious collection was brought together in the main by Francis Charles, third Marquess, and Richard, fourth Marquess of Hertford. It was, however, largely added to and in many essential respects reorganised by the late Sir Richard Wallace, to whom it had passed by bequest. The European armoury, unique of its kind in England, is entirely his creation The Masters of the French School of Painting of the 18th century, especially Watteau, Lancret, Pater, Le Moine, Oudry, Nattier, Boucher, Fragonard, and Greuze, are represented as they are in no public or private gallery in Europe, except that of the Louvre, and even the latter in this respect is surpassed in several important particulars by the Wallace Collection. The collection of Sévres porcelain is amongst the finest in the world, only paralleled by the collections at Windsor Castle and

(Continued on page 176.)

174

Louis XIV. **CHAIR AND ORNAMENT.** Late 17th Century.

Ornament in Black Enamel by Gilles L'Egaré (about 1660).

Louis XIV. Chair, Carved and Gilt, covered in Ruby-coloured Velvet with Broad Gilt Braid, and with Gold Fringe, features peculiar to the Louis XIV. Style.

Useful Pieces of Louis XIV. Carved Ornament.

175

Louis XIV. **SEBASTIAN LE CLERC.** Late 17th Century.

Designs for Sedan Chair by Marot.

Louis XIV. **CARVED PANEL.** Last Half 17th Century.

Buckingham Palace. The collection of French snuff-boxes of the 18th century is also exceptional. The miniatures comprise some examples by the most renowned artists of the English and foreign schools. The sculpture includes, besides bronzes of the 16th and 17th centuries, works of the 17th and 18th centuries by Warin, Coysevox, Girardon, Bouchardon, Falconet, Houdon, and others. The examples of French furniture of all kinds, of clocks, garnitures, candelabra, candlesticks, bronzes, and ornamental objects of the 17th and 18th centuries stand alone. No single collection in France or England, whether public or private, affords such opportunity for the study of this branch of decorative art.

Louis XIV. ENAMELLING. Last Half 17th Century.

Augustine Charles D'Avilier, architect, was born in Paris in the year 1653 and died in 1700. He early manifested the bent of his genius. He started for Rome at the king's expense, but on his voyage there he was captured by the Algerian corsairs, and they put to the sword all the crew. D'Avilier was not liberated until about sixteen months after. Meanwhile he worked during his captivity. Among other very grand works, he designed a beautiful mosque, which was one of the principal buildings in Tunis. Arriving at Rome, after his liberation, he applied himself to measuring the ancient and modern buildings of that city. The knowledge which he thus acquired enabled him to produce a "Cours d'Architecture," a complete work, and one that was highly esteemed. He enjoyed a great reputation, and was awarded a pension. Some designs for Balconies, Pavements, etc., from his pencil will be found on pages 47 and 48.

Black enamel was used in goldsmiths' work as a decoration to show off the precious metals, and is a kind of damascene work of an extremely delicate and beautiful character much in vogue at this period. The goldsmiths first had the face of the precious metal deeply cut on lines on which they had previously traced the design. The enamel was composed of a mixture of sulphur, copper, lead, borax, and silver, and this composition was poured into the incisions made in the metal. Any projection of the enamel was filed down to the level of the metal. This art is very ancient, and was well-known and practised by the Romans. Some specimen designs are given above.

178

Louis XIV. LEGS OF CONSOLE TABLES. Last Half 17th Century.

Sebastian Le Clerc, designer and engraver, was born at Metz in 1637, and died in Paris 1714. His father was a clever designer, and it was under his tuition that he was brought up. Though he was an adept with the pencil and the brush, it is chiefly as an engraver on copper that he is known. He appears to have been much employed by the government in engraving plans of cities, etc. He came to Paris and asked the aid of the celebrated Le Brun, who found him employment, and that gave him a pen and lodgings at the Gobelins; his XIV. also gave him an honorary position. He did a considerable amount of work, which is well designed, of a good proportion, and fairly suits the Louis XIV. style.

Some of the following I make are copied from an "Historical Notice on the Manufacture of tapestries and carpets made at the Gobelins Handbook on "Tapestry," by Alfred de Champeaux. A description of the modelled in close proximity. The first are placed in a Factory will be read with interest. The coloured wools and silks used are

179

Louis XIV. **LEGS OF CONSOLE TABLES, ETC.** Last Half 17th Century.

Louis XIV. **ARMCHAIR AND CARVINGS.** Last Half 17th Century.

Gilt Armchair in **V**elvet with Gold Braiding.

warehouse in hanks; the second in a retail shop where they are stretched on pegs belonging to the employees. Moreover, to each loom is attached a particular cupboard wherein are placed the wools assorted by the artist for his work and other odd pieces that might still be useful in the tapestry on the loom. The workmen, independently of the weaving of the tapestries, execute for themselves all that appertains to the fabrication. They plan the warp and put it on the loom, they trace the outline and transfer their design, assorting the coloured wools which they will want. The looms, called the "high-warp," employed in the manufacture of tapestries and carpets differ very little in their sizes or details. The most important are those on which carpets are manufactured, the dimensions being regulated by the size of the carpet to be manufactured, sometimes 30 feet long or more.

Louis XIV. **ARMCHAIR AND CARVINGS.** Last Half 17th Century.

Those to take tapestries are from 12 feet to 21 feet or more in length (see No. 1, page 189). They are composed of a pair of strong cylinders of oak or deal, called lisses, placed horizontally in the same vertical plane, and at some distance from one another (from 7 feet to about 8 feet apart), supported by double uprights in oak, and established in such a manner as to allow them to divert more or less, and so stretch the threads of the warp. The latter are rolled and fixed on the rollers by a curtain rod placed in a longitudinal groove cut out in the length of the roller. It takes great knowledge how to fix the warps, and it is of much too technical a nature to be explained here. The warp is sometimes vertical and sometimes horizontal. It is wound round the top cylinder of the loom, the web as it is finished being wound round the lower one.

It is impossible in a work like this to give anything like a detailed description of the manufacture of tapestry, which must be sought in works devoted to that purpose, such as the two books already mentioned, Lacordaire's being especially complete as far as relates

Gilt Armchair in Damask.

182 Louis XIV. **CHAIRS.** Last Half 17th Century.

Gilt Armchair in Cut Velvet.

Gilt Chair in Damask.

Louis XIV. **PRIEU DIEU AND CARVING.** Last Half 17th Century.

to the Gobelins, of which he was the director from 1850 to 1860. I will, however, mention some of the chief points.

Tapestry, like all woven fabrics, is composed of a warp and a woof, but the woof alone appears on both the wrong and the right side, because it must entirely cover the warp. In the high-warp looms the warp is composed of worsted, cotton, or silk threads, of four or five yarns twisted together, and it must be perfectly smooth. When stretched upon the rollers the workman divides it into leaves, which are kept apart by a thread passed alternately between the threads of the warp (see *a*, No. 2, page 189) and by a glass tube, two or two and a half centimetres in diameter, called the baton de croisure (see *b*, No. 2). In consequence of this separation half the threads of the warp are brought in front, while the other half fall behind.

Gilt Prieu Dieu Chair in Velvet with Gold Braiding.

To each thread of the leaf, at the height of the workman's hand, is attached a bit of fine cord in the shape of a ring, called a coat (see *d*, No. 2), and these coats are fastened to a strong pole, called the coat stave (see *c*, No. 2). It is by drawing these coats forward that the workman, who is seated between the warp and the picture which he is copying, can bring the back threads forward, so as to enable him to cross the warp and the woof. The material for the woof is wound on a wooden shuttle, called a broach or flute (see *f*, No. 2). To form the web, the workman takes a shuttle mounted with wool or silk, the end of which he fastens to the warp to the left of the space to be covered by the colour in his shuttle; then passing his left hand between the two leaves separated by the baton de croisure, he draws towards him the threads which this shade is to cover. His

(Continued on page 187.)

184

Louis XIV. **SETTEE AND ARMCHAIR.** Last Half 17th Century.

Gilt Settee at Fontainebleau.

Gilt Chair at Fontainebleau.

Louis XIV. **DETAILS OF SETTEE AND CHAIR.** Last Half 17th Century.

Details of the Settee and Chair illustrated on opposite page.

186

Louis XIV. **CARVINGS.** Last Half 17th Century.

Louis XIV. **CARVINGS.** Last Half 17th Century.

right hand passing between the threads, lays hold of the shuttle, which he brings to the right, and his left hand taking hold of the coats brings forward the back threads of the warp, while the right hand returns the shuttle to the place from which it was first moved. This passing and returning of the shuttle forms what is called two shoots or a course.

A fresh shuttle is used for each different shade. After each course he closes with the sharpened end of his shuttle the threads of that part of the web already completed, and finally strikes the woof with a comb of ivory with sufficient force to penetrate between each thread of the warp, and by this means causes the warp to be concealed by the woof. The workman tries to get the effect of hatching by passing from one colour to another by shades that partake of both; otherwise the result would be too staring and crude. This is one of the great difficulties of tapestry weaving. It is said that it takes about fifteen years to train a workman in the Gobelins manufactory, and that some families have been employed for generations. This is why such high perfection has been attained in the manufacture of storied tapestries. The process is so difficult that it sometimes takes a highly skilled workman a year to produce three or four yards, and the average annual task is one and a half yards. A large design therefore takes years to complete; and when we consider the workman has to choose from about 14,000 shades this is not surprising.

Louis XIV. **CARVING AND FIREDOG.** Last Half 17th Century.

Carving.

Firedog at Fontainebleau.

Louis XIV. **TAPESTRY WEAVING.** Last Half 17th Century.

Francis I. is credited with introducing tapestry weaving into France, and he it was who established a factory at Fontainebleau, with Flemish workmen. After his death, Henry IV. continued to give it his countenance, and about the year 1601 he encouraged a number of Italian and Flemish workmen to settle in Paris. It was not until about the year 1630 that the Gobelins was established, and about the same year a carpet manufactory was also started at Chaillot, called the Savonnerie, from the premises being originally a soap factory. As regards the carpets made at the Savonnerie, they differ entirely from the tapestries of the Gobelins in that tapestries are placed on walls, and being seen as a whole more easily than carpets they naturally take after a picture. It is held as a reproach to the Gobelins tapestry of the middle or latter half of the 18th century, that it was entirely out of harmony with the true character of tapestry weaving. The workmen tried to imitate all the evanescent tones of a picture after Boucher, with the result that these delicate shades have quite faded or disappeared. It was their mastery of technique which encouraged this evil practice.

No. 1.

High-warp Loom for the manufacture of Gobelins Tapestry.

The same evil practice obtained at the Savonnerie. The carpets made there are claimed to be velvets. The workman sees the right side of the carpet, not the wrong, as in the weaving of tapestry, where the outline of the design is traced in black crayon on the stretched threads, and which is done a small portion at a time.

High-warp looms are employed, and the warp of the carpet is wound vertically on two cylinders, and arranged as in the looms for tapestry, but the worsted threads composing the woof, which are to form the surface of the carpet, are fastened by a double knot on two threads of the warp. The latter is of wool and double, and it combines itself both with a warp and a weft, no part of which appears on the outside. To make the stitch the workman takes a shuttle, and separates with his left hand the thread of the warp on which he is to begin, and draws it towards him; he then passes the shuttle and the worsted thread which he holds with his right hand behind; this done, he advances by means of the coat the next thread of the warp, round which he makes a running knot, which he tightens.

No. 2.

Louis XIV. **TAPESTRY WEAVING.** Last Half 17th Century.

Between these two shoots the wool forms on the front of the warp a ring, the diameter of which is according to the height of the pile. A round wire, sharp at one end, is then passed through this ring or loop, and a row of rings is then formed on it by the repetition of the stitch. By drawing the wire from left to right all these loops are cut and the pile is formed. When a row of stitches is thus completed, the workman binds them by means of a strong hempen thread thrown between the two leaves of the warp and placed above the stitches. He then intersects the thread of the warp by another hempen thread, forming the weft; and to do that he advances, by means of the coats, the threads that are behind. He passes the woof between the two rows of threads, and allows the hinder ones to resume their former place. In this manner each of the stitches is, as it were, linked together. This being done, he strikes the stitches and hempen threads with a comb, and these latter are thus forced inside the fabric so as to be invisible. Then the clipping or shaving of the carpet takes place, which is necessary from the unequal length of the ends of wool left in cutting the loops of the pile. This operation requires much precision on the part of the workman, and has an important bearing on the beauty of the carpet. The productions of the Savonnerie being generally larger than the other pieces of Gobelins tapestry, the looms in which they are made are also larger, and allow of several workmen being engaged at the same time, thereby accelerating the progress of the work.

No. 4.

Side from which the Tapestry artist works.

As regards the low-warp loom, which is used by weavers who produce their work on a commercial basis, I must refer the reader to a work treating on tapestry generally. The high-warp was only made at the Gobelins, and it is more suitable for the carrying out of imposing schemes like the pictures of great painters—Le Brun, for instance, who designed on a very ambitious scale. Low-warp tapestry is done much more quickly than high-warp, and is made in smaller pieces and joined together. It is curious that the best wools come from Kent, and these were used in the finest productions, especially at the Gobelins, and they are so used at the present time. At Beauvais, Aubusson, and Felletin, tapestry making was done on a more commercial basis than that at the Gobelins.

Tapestry weaving had early developed among the Flemish, one of the reasons being that they received such excellent wool from England. It was the Flemish that started the art of storied tapestry, taking their

Louis XIV. **TAPESTRY WEAVING.** Last Half 17th Century.

subjects from the ancient fables, the tales of chivalry, &c. Their most noted place for the manufacture was Arras. Further particulars are given on page 202.

No. 3 on page 190 represents in plan and elevation the tissue of the tapestry. In F 1, which represents a section of the tissue, the warp is indicated by the letters B B, and by a series of small circles, the woof by the cord which envelops these circles. The illustration above shows the woof in perspective. No. 4 shows the side on which the workman is placed, always on the wrong side of the material. In No. 5 on this page, B is the shuttle and C the heavy comb of ivory, the use of which has already been explained. No. 6 and No. 7 show the system of hatching, which is done, as already explained, to prevent the appearance of mosaic, which would result from placing the colours close together. No. 8 is a high-warp loom for carpets. No. 9 on the next page shows the mode of

No. 5.

Tools employed in the manufacture of Carpets.

No. 6.

Showing the way the Hatching is done.

No. 7.

Showing the effect of the Hatching.

No. 8.

High-warp Loom for the manufacture of Gobelins Carpets.

Louis XIV. **TAPESTRY WEAVING.** Last Half 17th Century.

No. 9.

Mode of manufacturing the Carpets of the Savonnerie aux Gobelins.

No. 10.

Tools employed in the manufacture of Carpets.

No. 11.

Showing the way the Pile is made.

manufacturing carpets at the Savonnerie aux Gobelins. As already mentioned, the workman operates from the right side of the material, and not as in the case of weaving tapestry. No. 11 shows how the loops are cut to form the pile of the carpet.

No. 10 shows the instruments used in tapestry weaving.

G is the knitting needle on which is wound the coloured wools.

The tranche-fil (D) is made of a blade of iron rounded and armed at one of its extremities with a cutting blade.

The comb (E) is in iron and serves to compress the tissue.

The scissors (L) are for shaving and cutting the velvet.

The pressing needle is at F.

The needle (H) serves to repair those isolated parts which for any reason may have to be recommenced in a part of the finished tapestry.

Regency.　　　　　　　　　**WATTEAU.**　　　First Quarter 18th Cent

.. The characteristic feature of French Art during the first part of the 18th century was its *genre* painting, which for the most part took the form of fêtes champêtres, and the most eloquent exponent of this captivating branch of art was Antoine Watteau. He became the delineator of the courtly manners and amusements of his day, as represented by the masquerades and Arcadian affectations which were at that period so much the rage.

Antoine Watteau, the son of a tiler, was born at Valenciennes on the 10th of October, 1684. His father having sent him adrift, he made his way to Paris. He appears there to have turned out drawings at so much a dozen, but was nevertheless a great student, and it was at this time that he laid the foundation of that facility which was afterwards one of his marked characteristics. In the first years of the early 18th century he found his way into the studio of Claude Gillot. He became a member of the French Academy in 1714. He paid a visit to England in 1719. He died at Nogent, near Paris, 18th July, 1721. I have copied the criticisms of Horace Walpole on Watteau, as I think his remarks are very shrewd and to the point :—

"England has very slender pretensions to this original and engaging painter, he having come hither only to consult Dr. Meade, for whom he painted two pictures that were sold in the doctor's collection. The genius of Watteau resembled that of his countryman D'Urfe. The one drew and the other wrote of imaginary nymphs and swains, and described a kind of impossible pastoral, a rural life led by those opposites of rural simplicity, people of fashion and rank. Watteau's shepherdesses, nay, his very sheep, are coquet ; yet he avoided the glare and clinquant of his countrymen; and though he fell short of the dignified grace of the Italians, there is an easy air in his figures, and that more familiar species of the graceful which we call genteel. His nymphs are as much

Design for Decorative Panel.

WATTEAU. First Quarter 18th Century.

LA BALANCEUSE

Design for Decorative Panel.

below the forbidding majesty of goddesses, as they are above the hoyden awkwardness of country girls. In his halts and marches of armies, the careless slouch of his soldiers still retains the air of a nation that aspires to be agreeable as well as victorious.

"But there is one fault of Watteau, for which, till lately, I could never account. His trees appear as unnatural to our eyes, as his figures must do to a real peasant who had never stirred beyond his village. In my late journeys to Paris, the cause of this grievous absurdity was apparent to me, though nothing can excuse it. Watteau's trees are copied from those of the Tuileries and villas near Paris; a strange scene to study nature in! There I saw the originals of those tufts of plumes and fans, and trimmed-up groves, that nod to one another like the scenes of an opera. Fantastic people! who range and fashion their trees, and teach them to hold up

Regency. **WATTEAU.** First Quarter 18th Century.

Designs for Decorative Panels.

their heads, as a dancing master would, if he expected Orpheus should return to play a minuet to them."

Claude Gillot was born at Langres in 1673, and he was for some time master to Antoine Watteau. He received him into his house, taught him all he knew, and by and by the scholar surpassed the master. Gillot was a scholar of J. B. Corneille. He chiefly excelled as a designer and etcher of satyrs, fauns, and grotesques. His engravings are executed in a bold, free style. He engraved the plates for the "Fables" of La Mothe-Hendarò. His engravings amount to a considerable number. He died in Paris in 1722.

196
Regency.

WATTEAU.

First Quarter 18th Century.

Designs for Decorative Panels.

197

Regency. **WATTEAU.** First Quarter 18th Century.

Designs for Decorative Panels.

198
Regency. **WATTEAU.** First Quarter 18th Century.

LE RENDEZ VOUS

L AMUSEMENT

Designs for Decorative Panels.

Regency. **WATTEAU.** First Quarter 18th Century.

Designs for Decorative Panels.

200
Regency. **WATTEAU.** First Quarter 18th Century.

Designs for Decorative Panels.

Regency. **WATTEAU.** First Quarter 18th Century.

Design for Ceiling.

Regency. GILLOT. First Quarter 18th Century.

La Fête de Diane. Design suitable for Gobelins or Beauvais Tapestry or for Wall Decoration.

Tapestry is neither weaving nor true embroidery. Though wrought in a loom and upon a warp stretched along its frame, there is no woof thrown across the threads with a shuttle, but the weft is worked with many short threads of various colours put in with a needle. With the 14th century came the rise of great French and Flemish tapestry makers in Paris, Arras, and Brussels, and from that time it became quite the rage. The tapestries made at Arras were considered the best on account of their superiority in dyes and fabrics. Tapestry works sprang up in different parts of Europe, and immense sums of money were spent on its production. Tapestry with its beautiful designs suited well the carved oak surroundings in halls and bedrooms, and it was among the most esteemed treasures of the nobility, etc. The factories of Arras were ruined when the inhabitants of that town were expelled in 1477. During the 17th century Brussels declined and Paris became the chief centre.

It was in 1667 that Colbert persuaded Louis XIV. to buy the factory owned by a family of the name of Gobelins, who originally came from Rheims to Paris in the 15th century and settled on the banks of the little River Bievre and started business as dyers, the water of this stream having been found to possess excellent qualities for dyeing. The late M. Chevreul brought the art of dyeing to a great degree of perfection, he being attached to the dyeing department of the Gobelins. Later the Gobelins associated with themselves two

Regency. **GILLOT.** First Quarter 18th Century.

Flemish master weavers and began the manufacture of tapestry. Colbert styled the factory " Manufacture royale des meubles de la Couronne," and as the title indicates, it was not conducted solely for the production of tapestry. In fact the superintendent was invited to employ the best painters, tapestry makers, gold and silver smiths, founders, engravers, lapidaries, cabinet-makers in ebony and other woods, dyers, and the best workmen of all arts and trades. So that Colbert's idea was to manufacture not only the best kinds of tapestries, but also all kinds of the best furniture —both carved and inlaid with marqueterie; the most superb bronzes and all sorts of gold and silver smiths' work of the very highest quality. We find in the tapestry made at the Gobelins, representing " The visit of Louis XIV. to the Gobelins,"

Design for Decorative Panel.

Regency. **GILLOT.** First Quarter 18th Century.

Design for Decorative Panel.

groups of these artists offering to the King cabinets, tables, magnificent vases, rich mosaics, and those incomparable tapestries which during two centuries were to cover the factory with an imperishable glory. Colbert appointed Charles Le Brun the director of this model manufactory. He was a painter of the greatest talent, and most of his heroic compositions were there produced in gorgeous tapestry. As long as Colbert lived the manufactory was in all its glory. The furniture produced was of a prodigious richness, the silver work of a magnificence without precedent. It is to this time that we owe the series of tapestries known all the world over as "L'Histoire du Roi," "Les Residences Royales," "Les Saisons," "Les Elements," "L'Histoire d'Alexandre," "L'Histoire du Constantin," etc.— reckoned still among

Regency. **GILLOT.** First Quarter 18th Century.

the series the most magnificent and the most perfect known. But in 1683, Colbert, imbued with disgust and suspicious of his master, was filled with chagrin, especially when Louvois, who wanted his place, took advantage of his privilege of constantly seeing the King to persuade the latter to let him succeed Colbert. After this all was changed. The new superintendent was a man of little taste and of no artistic education, and these two defects were sufficient to hasten the decline of the royal manufactory. Louvois not only detested Colbert, but carried his hatred to his works and to his assistants. He was unable to forget the pains that Colbert had taken to raise Le Brun and to develop the grand and prolific establishment which he directed. In 1685, while the finances were still prosperous, he had suppressed the wiring of gold and silver in the tapestries, which until then had been enriched with the precious metals.

In 1686, by his direct order, he abruptly stopped a piece called "L'Histoire du Roi," for which Le Brun had himself made the designs.

Design for Decorative Panel.

Design for Decorative Panel.

He hoped by this action to have forced Le Brun to resign. Still, when he had, in order to maintain his waning influence, launched his master into those interminable wars and commenced the ruin of France, he did not hesitate to sign, in 1689, the order which sent all those marvellous pieces of goldsmiths' work, which had taken fifteen years' labour to do in the Gobelins workshops, to be coined into money. In the same year Le Brun died, and Mignard was appointed director of the Gobelins. Mignard's administration was less productive than Le Brun's. He was sixty-eight years old when he was called to take on his weak shoulders this heavy charge. He had not the activity nor the style of genius which suited such an enterprise. Further, the money indispensable to the proper conducting of so great an under-

Regency. **GILLOT.** First Quarter 18th Century.

taking was wanting. Therefore, it is not astonishing that under the superintendence of Louvois and of that of Villacerf, his successor, and under the direction of Mignard and of his substitute, the Gobelins were passing through a great crisis. This crisis lasted a long time, and it was these troubles continually cropping up from time to time that brought about the ruin and disappearance of the celebrated establishment. The personnel was partly licentiate. Many of these emerited artisans passed over to the foreigner; others were engaged in the King's army. At one period, when the precious metals were found to be very scarce, the goldsmiths were the first to find themselves without work. The cabinetmakers, the painters, the carvers had to seek outside the establishment for the employment of their talent. So that, with the exception of the tapestry rooms, where work was continued, from this period the grand creation of Colbert had nearly ceased to exist. The times, moreover, of these grand works, which called for the co-operation of all the

Design for Decorative Panel.

Design for Decorative Panel.

most brilliant and noble in industry and art, were past.

By the death of Louis XIV., the finery of the coquet was substituted for worship of the great in style. Instead of furniture of silver and of silver gilt, furniture of Japan ware became the fashion. Le Sieur Dagly, who imported into France the secret of how to make it, was lodged at the manufactory in 1713, and his production, which took the name of Vernis de Gobelins, remained a secret for a long time. Among the tapestries carried out under Mignard were "La Galerie de Saint Cloud," which were designed by him for the grand gallery of that chateau; and the "Tenture des Indes," which are numbered among the most beautiful series carried out at this period by the Gobelins. Mignard died in 1695, and at the same time the prestige attached to the

Gobelins and Beauvais. **JEAN-BAPTISTE OUDRY.** 18th Century.

name of this master vanished. When Mansart and Robert de Cotte succeeded Villacerf and Mignard, the staff was dispersed, the manufactory disorganised, the workshops empty and deserted. They appear to have done very little, but continued to produce the "Tenture des Indes" and the "Mois grotesques d'Audran." Later Louis XIV. appointed himself as director, with the Duke d'Antin under his orders.

D'Antin, aided in this new task by Jules Robert de Cotte, upheld the fame of the Gobelins until 1736. Under his influence they took up again and completed the admirable sets of "L'Histoire du Roi" and the famous "Tenture des Indes," and they executed the two sets of "L'Ancien et du Nouveau Testament." The success given to the production of the Gobelins by the Duc d'Antin was continued under his successor, the Comptroller General Orry. It was at this time that "L'Histoire d'Esther" was produced, which had a very great success, and also the famous set of "Don Quichotte," designed by Coypel. The cartoons for these are still at Compiegne.

1.—Different Animals before the Bust of La Fontaine.

2.—The Grasshopper and the Ant.

3.—The Raven and the Fox.

4.—The Town Rat and the Country Rat.

The entire set extended from twenty-one to twenty-eight pieces, and had so great a success with the public that it permanently occupied the looms from 1739 until about 1830. The repetitions were varied by change of colour in the ground, and also by the design of fresh borders, these borders being a great feature in every design from the Gobelins. Under Orry old models were renewed.

Gobelins and Beauvais. **JEAN-BAPTISTE OUDRY.** 18th Century.

5.—The Man and his Image.
By M. le Duc de la Rochefoucault.

6.—The Man between Two Ages and his Two Mistresses.

7.—The Fox and the Stork.

8.—The Child and the Schoolmaster.

The eight subjects of "Les Nouvelles Indes" were then begun by Francois Desportes. "Les Fragments de l'Opera," by Coypel, were next put in hand. Examples of the above, together with another set that were made at this time, can be seen at Windsor, the second set being De Troy's "Story of Jason and Medea." About this time arose the desire to produce "pictures" by which the workmen of the Gobelins were led astray from the true art of tapestry. Oudry was asked to superintend the execution of his paintings in tapestry at the Gobelins, and he is credited with hastening the rapid progress in this wrong direction. A royal "Chasse" was designed by him which was reproduced at the Gobelins, and included a portrait of the king and of all the nobles who accompanied him.

About this time (1734) Oudry was appointed one of the superintendents of the Beauvais tapestry factory, which had also been established by Colbert. Among the designs by Oudry were "Les Amusements Champêtres," "Les Comediens de Molière," "Les Métamorphoses," and "Les Fables de La Fontaine." Some of the last, in Beauvais tapestry, can be seen on some of the chairs in the Wallace Collection at Hertford House, London, among them "Le Singe et le Dauphin," "Le Cheval et l'Ane," "Le Corbeau et le Renard." Other designs to be seen there belong to the set "Les Chasses," such as stag hunting; and some simpler subjects such as rabbits, wild duck, fox and cock, spaniel and wild duck, love's emblems, garlands of roses, etc., etc. This class of design could be used for chair and sofa seats and backs, and so had a more extended sale than the more ambitious designs, and thus promoted the commercial prosperity of this factory. It is said that Oudry made the

Gobelins and Beauvais. **JEAN-BAPTISTE OUDRY.** 18th Century.

drawings for La Fontaine's fables in the evenings spent by him at Vauré. Boucher helped Oudry with designs, which were a great success. Oudry was in business partnership with Besnier in the Beauvais factory, and it is reported that after twenty years' partnership Oudry had secured 100,000 lt. as his share.

Some designs of Beauvais tapestry can be seen on the chairs bequeathed by Mrs. Lyne Stephens at the Victoria and Albert Museum. Oudry had the superintendence at the Gobelins of hangings from the "Story of Esther," which were designed by De Troy. This was one of the series where Oudry broke away from the old traditions of the tapestry workers, his idea being that the tapestries should be, as near as possible, exact reproductions of the pictures in tone and colour. One of the results of this was increased expense, the painter, in getting his "effects" of colouring, not troubling himself about or not knowing the practical difficulties in the way of executing his "dreams of colour," and, although some of the new designs were charming, the tapestry workers, in order to produce the delicate effects, had to do so

9.—The Cock and the Pearl.

10.—Against those who are difficult to please.

11.—The Wolf pleading against the Fox before the Monkey.

12.—The Cock and the Fox.

with soft and fugitive colours. Further, where the early weavers had contented themselves with nineteen colours, the eighteenth-century weavers had an assortment of a thousand colours, each sub-divided into twelve shades from dark to light. The result was, that after a time some of the more delicate hues faded away altogether, thereby spoiling the effect. This brought the factory into disrepute. The older tapestries, however, are much prized, and fetch enormous, even fabulous, prices, but, of course, their colourings have stood.

Gobelins and Beauvais. **JEAN-BAPTISTE OUDRY.** 18th Century.

13.—The Raven wishes to imitate the Eagle.

14.—The Peacock complaining to Juno.

15.—The Miller, his Son, and the Ass.

16.—The Miller, his Son, and the Ass.

Under Louis XV. tapestry designs changed their character. Instead of tableaux of pomp, grandeur, victory, battle scenes, etc., softer and more coquettish subjects, such as love and pastoral scenes, as portrayed by Watteau and Boucher, were in favour. Boucher succeeded Oudry in 1755 at the Gobelins, but not at Beauvais, and he appears to have followed the ideas of Oudry. It appears that Gerspach, carrying out the analysis of a tapestry work executed at the Gobelins in 1676, took as the base of his calculations only ten shades to each scale of colour, and tells us that the old carnations had lowered but one half to two shades, that some violets had lost their reds, some yellows, as is the fatal propensity of yellows, had turned grey, but that the vast majority of the hues employed had scarcely changed. This speaks well for the older tapestry. In this old tapestry strong rich colours were used. Early examples, either from Beauvais or the Gobelins, show the fine red browns, the clear carnations, etc., and this is partly why these older tapestry colours faded less. But in the later period, the mania for " great lightness " had the inevitable result. These delicate hues were evanescent. Boucher, in later life, framed his centres of warm light in pale greens and yellows, and detaching on them hues of rich rose red with a touch of dark blue. Among the designs of the Beauvais factory of a later date, the effects have a tendency towards an " all over alike " appearance.

213

Gobelins and Beauvais. **JEAN-BAPTISTE OUDRY.** 18th Century.

17.—The Mouse transformed into a Girl.
18.—The Oyster and the Suitors.
19.—The Partridge.
20.—The Burier and his Confederate.
21.—The Miser who had lost his Treasure.
22.—The Woodman and Mercury.
23.—The Little Fish and the Fisherman.
24.—The Satyr and the Passer-by.

214
Gobelins and Beauvais.　　　　JEAN-BAPTISTE OUDRY.　　　　18th Century.

30.—The Amorous Lion and Mademoiselle de Sevigne.

29.—The Drowning Woman.

26.—The Wolf become Shepherd.

25.—The Miller, his Son, and the Ass.

32.—The Fly and the Ant.

31.—The Shepherd and the Sea.

28.—The Fox and the Grapes.

27.—The Drop and the Spider.

Gobelins and Beauvais. **JEAN-BAPTISTE OUDRY.** 18th Century.

215

33.—The Rat and the Elephant.
34.—The Horoscope.
37.—The Monkey.
38.—Belphegor.
35.—The advantage of Science.
36.—Jupiter and the Thunder Bolts.
39.—Wedlock and Love.
40.—The Fool who sold his Wisdom.

Gobelins and Beauvais.　　　**JEAN-BAPTISTE OUDRY.**　　　18th Century.

46.—The Monkey and the Leopard.

45.—The Monkey and the Leopard.

42.—The Fish and the Shepherd who played on the Flute.

41.—The Wolf and the Shepherds.

48.—The Sculptor and the Statue of Jupiter.

47.—The Acorn and the Pumpkin.

44.—Love and Folly.

43.—The Gods willingly instruct a Son of Jupiter.

Gobelins and Beauvais. **JEAN-BAPTISTE OUDRY.** 18th Century.

49.—The Man who stepped after Fortune and the Man who waited in his Bed.
50.—The Ingratitude and Injustice of Men towards Fortune.
51.—The Fortune-Tellers.
52.—The Cobbler and the Money Lender.
53.—The Power of the Fables.
54.—The Women and the Secret.
55.—The Laugher and the Fishes.
56.—Tircis and Amarante.

218
Gobelins and Beauvais **JEAN-BAPTISTE OUDRY.** 18th Century.

62.—The Ass carrying Relics.

64.—Jupiter and the Farmer.

61.—Fortune and the Young Child.

63.—The Sun and the Wind.

58.—Discord.

60.—The Bad Bridegroom.

57.—The Mole boasting of his Genealogy.

59.—The Young Widow.

Gobelins and Beauvais. **JEAN-BAPTISTE OUDRY.** 18th Century. 219

70.—The Daughter.

72.—The Wishes.

69.—The Fox and the Bust.

71.—The Heron.

66.—The Monkey and the Dolphin.

68.—The Gardener and his Master.

65.—The Jay dressed in the Feathers of a Peacock.

67.—The Stage Waggon and the Fly.

Gobelins and Beauvais. **JEAN-BAPTISTE OUDRY** 18th Century.

The looms at the Gobelins are of the kind known as "high - warp," in which the warp threads are vertical, as compared with "low-warp" looms, in which the warp threads are horizontal. Only three looms are now engaged in producing Gobelins tapestry proper. At these the reverse side of the tapestry is turned towards the workman, with the outline of the design drawn in black crayon on the stretched threads. At the workman's side are the pictures to be copied and a basket with wools of every colour and shade (about 14,000 tones in all). The weft-threads are inserted by means of shuttles held in the hand. In weaving the "tapis de la Savonnière" the workman has the copy in front of him and works on the right side of the tapestry. The weft-threads in this case are tied and then cut, producing a velvet pile. There are about forty workmen now employed, and a skilful workman can complete four square yards in a year, but the average annual task is about one and a half yards. Many years are, therefore, sometimes requisite for the execution of the larger designs, which when complete are worth from £2,000 upwards.

Aubusson and Felletin were two other noted factories where tapestry was made. The origin of the

Regency. **GILLES-MARIE OPPENORD.** Early 18th Century.

Design for Gobelins Tapestry or Wall Decoration.

Regency. **GILLES-MARIE OPPENORD.** Early 18th Century.

Design for Side of Room.

manufactory at Aubusson seems lost in the Middle Ages, but since about the 15th century it has enjoyed considerable notoriety. Nevertheless, little was known of the products of this manufactory previous to the 17th century. There is a contract, dated in 1625, by which a tapestry maker agrees to make a piece of tapestry enriched with flowers of silk to go over a chimneypiece, the subject being a scriptural one, generally chosen among the earlier tapestry makers. There are other contracts about this date, which seems to prove the making of tapestry was fairly general. We know that in 1666 Jacques Bertrand, of Aubusson, supplied Louis XIV. with a piece of tapestry enriched with gold, and many other pieces from the same town, all of which were made during his reign. It was in 1665 the same King authorised

Regency. **GILLES-MARIE OPPENORD.** Early 18th Century.

the factory to assume the title of "Manufacture Royale," and decided that an eminent artist and also one of the best tapestry makers should be sent from Paris to superintend the manufacture there. This wise decision remained, however, a dead letter. Colbert neglected his promises, and ere long, the revocation of the Edict of Nantes gave a decisive blow to this industry, although it continued to exist. About the middle of the 18th century the workers at this ancient royal factory were in dire distress; but, in spite of the vicissitudes it has gone through, it is still in existence, the French Government having two private establishments there, employing about 100 workers. The tapestries they turn out are used merely for Government purposes. This factory was mainly dependent on outside patronage, and was conducted on more of a commercial basis than the other state-aided establishments. The products of Beauvais had long been considered superior for certain classes of subjects to those of Aubusson, but it is claimed on behalf of the latter that the work it turned out from its

No. 1. No. 2.
Two Designs for Carriage Gates.

Regency. **GILLES-MARIE OPPENORD.** Early 18th Century.

No. 1. No. 2.
Two Designs for Doors.

factories has a national interest which cannot attach to the products of the other establishments, the famous " Jeux d'Enfants," by Corneille, in the Louvre, Paris, being quoted as a specimen of the high-class work that had been produced in the 17th century by the Aubusson workmen. As regards the Felletin tapestries, also known as Auvergne tapestries, the factory seems to have been in full swing during the whole of the 16th and 17th centuries. In an inventory of the year 1514 there occurs a description of "twenty-two pieces of tapestry of Felletin." It appears that about the middle of the 17th century the tapestries of Felletin were not much valued, and the low price they fetched was one of the reasons why this factory was gradually eclipsed by the greater fame of Aubusson. To-day the name of Felletin is hardly known, while that of Aubusson is justly celebrated. Many ambitious attempts have been made in various countries to establish tapestry weaving. One was started at Windsor under the late Queen Victoria, and it was

(*Continued on page 230.*)

Regency. **GILLES-MARIE OPPENORD.** Early 18th Century.

Designs for Ironwork (see page 232).

226

Regency. **GILLES-MARIE OPPENORD.** Early 18th Century.

Designs for Ironwork (see page 232).

227

Regency. **GILLES-MARIE OPPENORD.** Early 18th Century.

Designs for Ironwork (see page 235).

228

Regency. NICHOLAS PINEAU. Early 18th Century.

Designs for Girandoles.

Regency. **NICHOLAS PINEAU.** Early 18th Century.

Designs for Girandoles.

Regency NICHOLAS PINEAU. Early 18th Century.

Designs for Console Tables.

splendidly endowed. It received a good many important commissions, but extravagance in management led to its closing. The workmen from Windsor went to America and started a factory on the Bronx River, which was found to have the same qualities as the river where the Gobelins were established. French workmen also came to the assistance of the American factory, but it has been explained by a writer on the subject of tapestry-weaving that " the effort to educate American weavers, and to make the industry native and independent of foreign workmen, has met with a serious obstacle in the American dislike of the apprentice system. Tapestry weavers require a high degree of skill, great patience, and the most practised eye, and therefore for the first few years an employé, who is a novice, is of comparatively little value. In the French Gobelins works boys, in most cases the sons of the workmen (some families having been employed for generations in this industry), are apprenticed to the trade. The Government gives them a living and an education, and when they become proficient they receive good wages. In America a boy is in too great a hurry to learn a trade

Regency. **NICHOLAS PINEAU.** Early 18th Century.

first and get wages afterwards, and only through paying good wages from the start has it been possible to obtain American apprentices." The Gobelins, the state manufactory of the famous tapestry, is open to the public. It contains an interesting collection of ancient tapestries, including the famous "Louis XIV. visiting the Gobelins Factory" by Le Brun. The visitor who has seen nothing but faded old Gobelins tapestry of inferior kinds will be struck by the beauty and brightness of the colours and the delicacy of the shading of the tapestry he will see when he goes through the workshops there. The Garde Meuble in Paris is rich in tapestries, and all the palaces have examples in panels, hangings or on the backs of settees, chairs, etc. The days when these old tapestries were relegated to garrets and storerooms has gone by, the interest in them now being on the increase; and dealers are ready to pay fabulous prices for genuine old examples, in order to decorate the superb mansions which are being built for the rich in all parts of the world.

Designs for Brackets to hold Candelabra.

Regency. **NICHOLAS PINEAU.** Early 18th Century.

On page 225 will be found illustrations of iron balustrades, gratings, etc. In the top left-hand corner of the first set is an iron bracket to carry a sign-board; in the top right-hand corner is a design for a low grating. The design on the left is for a pilaster; those in the centre are for balustrades terminated with a console, and the design at the bottom of the page is for a balcony. In the second series on this page the top left-hand design is for a signboard; the top right-hand one is a small fire-guard for the best apartments; those in the centre are for balustrades terminating in panels. In the bottom left-hand corner is a design for an overdoor. The other four are for balusters. On page 226 in the first set the first design in top left-hand corner is to hold a sign-board; in the right-hand corner is a design for a grating. In the centre are two designs ending in consoles. On the right is a design for a pediment, and at the bottom are designs for heads of keys and door-knockers.

Side of Room.

Designs for Girandoles.

233

Regency. **NICHOLAS PINEAU.** Early 18th Century.

Brackets to hold Vases.

234
Regency.

NICHOLAS PINEAU.

Early 18th Century.

In the second series in the left-hand top corner is a bracket to hold a sign-board; in the right-hand corner is a design for a small fireguard for the best apartment. In the centre are two designs for balustrades ending in panels; to the left is a design for a shaped overdoor.

On page 227, in the first series, in the top centre is a design for an iron capital. In the centre are two designs for gates; below these are four designs for capitals, and at the bottom are two designs for fret friezes. In the second series on this page the first on the left is for a Prie Dieu; the centre is a design for a console table, and on the right is a church seat. In the centre on the left and right are given designs for

(Continued on page 238.)

Designs for Chantournés (Heads of Beds).

Designs for Medallier.

Regency. **NICHOLAS PINEAU.** Early 18th Century.

Designs for Canopies of Beds.

236

Regency. **MANSART.** First Half 18th Century.

Designs for Chimneypieces.

Designs for Pier Glasses.

237

Regency. **MANSART.** First Half 18th Century.

Designs for Chimneypieces with fitted Bookcase.

Designs for Chimneypieces.

Regency. MANSART. Early 18th Century.

Design for Chimneypiece.

braziers for use in churches; at the bottom are two designs for console tables, and a design for a Paschal chandelier.

Nicholas Pineau was born in 1684 and died in 1754. He was a pupil of Mansart and Boffrand. He was a wood-carver, and is credited with doing the greater part of the carvings for the Hôtel de Soubise. It appears that Peter the Great solicited the French Government to send him some special workmen to Russia, his imagination having been fired by the "Chateau de Versailles," and among these workmen was Nicholas Pineau, who stopped there a number of years, but finally returned to Paris, where he met with much success. On pages 228 and 229 will be found some Girandoles by Nicholas Pineau. The frames are very elaborate, which was partly due to the rarity of glass. Although somewhat in general use in the palaces, etc., glass was still of sufficient importance to merit good surroundings. These girandoles were probably made in soft wood and gilt, and the gilding has the merit of softening down features of a design that might otherwise become obtrusive, as in these designs the grotesques, the mascarons, shells, feathers, etc. It is curious that in my "English Furniture, etc., during the 18th Century," I have shown some designs by Batty and Thomas Langley (page 67) in which the same features are represented as in these designs, the grotesques, for instance. Knowing that the Langleys only reproduced other people's designs, I have wondered where they obtained their ideas. These designs appear to give the solution. The mascaron was a head or mask placed in a central position, as over the centre of a doorway or in the centre of a pediment, etc., and was much used during this and earlier periods. It was a grotesque, sometimes laughing, sometimes merely making a grimace. The above remarks are equally applicable to the console tables and brackets depicted on pages 230 and 231. These were, no doubt, made in compo and several copies taken. They were probably by the Italian workmen who were then practising in France. The designs have the Italian feeling, and they could hardly have been carved in wood, as they would have been too costly. On page 232 is a typical side of room belonging to the Regency period, with a low dado, tapestry panelled walls, and the chimneypiece continued right up to the cove of the ceiling. The girandoles and the brackets and stands for china on page 233 are also representative of the Regency style. On page 234 are what were called "Medalliers," that is cabinets for coins or medals. On

(*Continued on page* 241.)

Regency. **M. DE CHAMBLIN.** Early 18th Century.

Designs for Sides of Rooms.

240

Regency. **JACQUES LA JOUE.** Early 18th Century

The Shipwreck.

Fruits of Autumn.

241

OAK SCREEN AT THE VICTORIA AND ALBERT MUSEUM.

Regency. First Half 18th Century.

pages 236, 237, and 238 are designs for chimneypieces, etc., by Mansart. There were many members of this family, and it is doubtful to which one these designs should be attributed. I think it was probably Jules Hardouin-Mansart, who was born in 1646 and died in 1708. The designs, however, seem later. This Mansart studied architecture with Francois Mansart and Libéral Bruant. He was appointed architect to Louis XIV. in 1675, and was much employed at Versailles—in fact, up to the time of his death. He was also employed

Regency. ORMOLU MOUNTS. Early 18th Century.

Ormolu Handle on Commode (page 176).

Ormolu Mount on Commode (page 176).

Regency. **ORMOLU MOUNTS.** Early 18th Century.

Ormolu Mounts on Commodes (page 176).

on the Grand Trianon in the Park at Versailles. He had a son, called Jean Hardouin-Mansart de Jouy, who was born in 1700. These designs may have been by him. They are included in a work published by Pierre Mariette during the first half of the 18th. century.

La Joue was a painter of architecture, who seemed to have a ready sale for his works. He was born in 1687, and died in 1761.

Fireplace and Glass, Sconces, and Fireback.

245

Regency. J. B. LE ROUX. First Half 18th Century.

Fireplace and Glass, Fireback, and Firedogs.

Fireplace and Glass and Fireback.

Regency. **LANCRET AND AUDRAN.** Early 18th Century.

The Music Lesson, by Lancret.

Decorative Overdoor.

April, by Audran.

247

Regency. **CRESSENT.** Early 18th Century.

Overdoor. Clock (see page 249).

248

Regency. **COTELLE AND AUDRAN.** First Half 18th Century.

Regency. **WARDROBE.** First Half 18th Century.

On page 252 is shown a commode in inlay of various woods, with mounts and ornaments of gilt bronze, cast and chased, by Charles Cressent (1685-1768), cabinet-maker to Philippe d'Orleans, Regent of France. This is a typical example of the work of this famous cabinet-maker in the style of the Regency, a period of transition between the Louis Quatorze and the Louis Quinze styles.

On page 242 is shown a magnificent clock by Cressent, in rosewood and satinwood, enriched with gilt bronzes, beautifully chased. These ornaments take capricious forms—very vigorous, and of a great originality—foliage, strings of pearls, rocailles (rock and shell), roses, seaweed, ovals, wings, clouds, etc., all grouped and relieved with an exquisite taste.

Oak Wardrobe at the Victoria and Albert Museum (style doubtful).

250

Regency. **OAK CHEST OF DRAWERS.** Early 18th Century.

Oak Chest of Drawers (Victoria and Albert Museum).

Regency. **WARDROBE.** Early 18th Century.

Oak Wardrobe (Victoria and Albert Museum).

Regency. **CRESSENT AND AUDRAN.** First Half 18th Century.

December, by Audran.

Commode with Ormolu Mounts, by Cressent.

October, by Audran.

Regency. **CRESSENT AND AUDRAN.** First Half 18th Century.

May, by Audran.

Medaillier, by Cressent.

September, by Audran.

254

Regency. **FRANCOIS LE MOYNE AND AUDRAN.** Early 18th Century.

Design by Francois Le Moyne.

Carving.

July, by Audran.

255

Regency. **JACQUES ABBADIES AND AUDRAN.** Early 18th Century.

February, by Audran.

Design by Jacques Abbadies, engraved by Charles Eisen.

March, by Audran.

Regency. **FRANCOIS LE MOYNE.** First Half 18th Century.

Louis XV. **JULES AURÈLE MEISSONNIÉR.** First Half 18th Century. 257

Side of Room, designed for the Polish Princess Sartorinski.

Jules Aurèle Meissonniér was born at Turin in 1695. He practised in Paris as an ornamentist and goldsmith. He carried the "baroque" to its greatest extravagance. The volume of Meissonniér designs for decorations of rooms and ornaments is very rare, but it has been reproduced. He held an appointment under Louis XV: He died at Paris in 1750.

Meissonniér had a large practice in Paris, and also designed for the nobility in other countries. He called himself painter, architect, sculptor, etc.

Initial Letters by Gravelotte.

258 · Louis XV. **JULES AURÉLE MEISSONNIÉR.** First Half 18th Century.

Side of Room, designed for La Baronne de Bezenval.

Louis XV. **JULES AURÈLE MEISSONNIÉR.** First Half 18th Century. 259

He designed a great amount of silversmiths' work, and his designs lend themselves more to this class of work than to furniture, etc. The latter have been justly condemned as extravagant, and some of them absurd; but he appears to have been much employed by Louis XV. and the nobility. His designs for the nobility of Poland, Portugal, etc., are considered to be more extravagant even than those he carried out for the French.

Initial Letters by Gravelotte.

Side of Room, designed for Le Comte Bielanski in 1734.

260 Louis XV. **JULES AURÈLE MEISSONNIÉR.** First Half 18th Century.

Two Designs for Wall Decoration and Clock.

Louis XV. **JULES AURÈLE MEISSONNIÉR.** First Half 18th Century. 261

Design for Side of Room.

Design for Console Table and Glass, etc.

262 Louis XV. **JULES AURÉLE MEISSONNIÉR.** First Half 18th Century.

Design for Console Table and Glass.

Design for Side of Room.

Louis XV. **JULES AURÈLE MEISSONNIER.** First Half 18th Century. 263

Design for Decoration made in 1730 for Louis XV.

Design for Sepulchral Monument made in 1733.

264 Louis XV. **JULES AURELE MEISSONNIÉR.** First Half 18th Century.

Design for Side of Room.

Design for Side Table and Wine Cooler.

Design for Console Table.

Initial Letters by Gravelotte.

Louis XV. **JULES AURÈLE MEISSONNIÉR.** First Half 18th Century. 265

Design for Side of Room. Snuff Boxes.

Settee designed for Le Comte de Bielanski in 1735.

266 Louis XV. JULES AURÈLE MEISSONNIER. First Half 18th Century.

Five Designs for Salt Cellars.

Six Designs for Watch Cases.

Design for Church Lamp.

Louis XV. **JULES AURÈLE MEISSONNIER.** First Half 18th Century. 267

Initial Letters by Gravelotte.

Designs for Surtouts, to stand in centre of Dining Table.

268 Louis XV. **JULES AURÈLE MEISSONNIÉR.** First Half 18th Century.

Three Designs for Salt Cellars.

Fourteen Designs for Snuff-Boxes.

Initial Letters by Gravelotte.

Louis XV. **JULES AURÉLE MEISSONNIÉR.** First Half 18th Century.

Initial Letters by Gravelotte.

Designs for Four Decorative Panels.

270 Louis XV. **JULES AURÈLE MEISSONNIÉR.** First Half 18th Century.

Designs for Candlesticks.

Designs for Picture Frames.

Louis XV. **JULES AURELE MEISSONNIÉR.** First Half 18th Century. 271

Designs for Candlesticks.

Designs for Sword Handles and Guards.

Designs for Decanters.

272 Louis XV. **JULES AURELE MEISSONNIÉR.** First Half 18th Century.

Cisterns and Tureens.

Initial Letters by Gravelotte.

Louis XV. P. E. BABEL. Middle 18th Century.

274

Louis XV. **P: E: BABEL.** Middle 18th Century.

275

Louis XV. **P. E. BABEL AND GRAVELOTTE.** Middle 18th Century.

Louis XV. Commode at the Chateau D'Eau.
Lacquer Panels and Brass Mounts.

Borders by Babel.

Initial Letters by
Gravelotte.

Louis XV. **N. LANCRET AND P. E. BABEL.** Middle 18th Century.

Spring.

Summer. Borders by Babel.

The Seasons by N. Lancret (1690–1743) in the Louvre.

P. E. Babel, a French designer and etcher, was born in Paris in the early part of the 18th century. It is reported he was a goldsmith as well as a designer and engraver of vignettes. He engraved numerous plates of ornamental decoration, and also designed and engraved decorations for books. His work was much admired. He died in 1761.

Louis XV. **NICHOLAS LANCRET.** First Half 18th Century.

Autumn.

Winter.
The Seasons by N. Lancret.

Initial Letters by Gravelotte.

Louis XV. **P. E. BABEL AND GRAVELOTTE.** Middle 18th Century.

Painting by F. Boucher (1703-1770) in the Louvre. Borders by Babel.

Initial Letters by Gravelotte.

Louis XV. **P. E. BABEL AND GRAVELOTTE.** Middle 18th Century.

Painting by F. Boucher in the Louvre. Borders by Babel.

Initial Letters by Gravelotte.

Louis XV.　　　P. E. BABEL AND GRAVELOTTE.　　　Middle 18th Century.

Borders by Babel. Initial Letters by Gravelotte.

281

Louis XV. **P. E. BABEL AND GRAVELOTTE.** Middle 18th Century.

Borders by Babel. Initial Letters by Gravelotte.

Louis XV. **P. E. BABEL AND GRAVELOTTE.** Middle 18th Century.

"Juno" by Charles Joseph Natoire (1700–1777) in the Louvre. Borders by Babel.

Initial Letters by Gravelotte.

Louis XV. **P. E. BABEL AND GRAVELOTTE.** Middle 18th Century.

"The Toilet of Venus" by F. Boucher (1703-1770) in the Louvre. Borders by Babel.

Initial Letters by Gravelotte.

Louis XV. C. D. J. EISEN AND J. E. NILSON. Middle 18th Century.

Louis XV. **J. W. MEIL, BABEL, AND GRAVELOTTE.** Middle 18th Century. 285

Border by Babel.

Initial Letters by Gravelotte.

Louis XV. **F. BOUCHER.** Middle 18th Century.

Louis XV. **F. BOUCHER.** Middle 18th Century.

288 Louis XV. **F. BOUCHER AND GRAVELOTTE.** Middle 18th Century.

Initial Letters by Gravelotte.

289

Louis XV. **JACQUES-FRANCOIS BLONDEL.** Middle 18th-Century.

Designs for Lampstands, etc.

Designs for Candelabra.

Louis XV. JACQUES-FRANCOIS BLONDEL. Middle 18th Century.

Jacques-Francois Blondel was born in 1705. He was one of the first French architects to promote the schools of architecture which have tended so much to advance that art in France. He was appointed architect to Louis XV. in 1755. Early in his career he was an architectural engraver. In later life, though designing in the Rococo style, he does not appear to have altogether approved of it. A noted work by him is "L'Architecture-francois," published in 1752. It was begun by Marot and continued by Blondel until eight volumes were completed. He died in 1774.

Designs for Escutcheons of Locks, etc.

On this page are some escutcheons of locks, etc. A is a plate with rosette to receive the button. B, keybits of locks, supported by ornaments underneath, which help to redeem the projection. C, keyholes of locks. D, a plate which forms the underpart of a swing bolt. E, a little bolt for cupboards or for windows. F, button to raise the latch of the doors. G, conduit to receive the rod of the swing locks. H, rod which with only one turn opens or shuts the door.

On page 291 is a working drawing of an espagnolette fastening for a casement window. A is the spiral screw-ring which receives the rod that is attached to the window sash. B, key-bit soldered to the rod, and which serves to fasten the clasps on to the shutter. C, the clasps on the upright frame of the shutter, which by means of the key-bit B firmly shuts on the sashes. D, the shoulder which serves to strengthen the rod at the beginning of the lacet A. E, handle which by only one operation opens or closes the window

Louis XV. **JACQUES-FRANCOIS BLONDEL.** Middle 18th Century.

and shutter. F, hollow socket which receives the rod which shuts door below. G, handle where the rod springs. I, cramp iron, in which the rod works backwards and forwards. K, the tie-piece, in which the above action shuts the hook of the espagnolette. L, the plate to which above is fastened.

Charles Etienne Briseux published several works on architecture. He was born about 1680 at Baume-les-Dames in Franche Comte, and died in 1754.

Some interiors, etc., designed by Briseux are illustrated on pages 296-303. These were mostly carried out in oak, and painted a light grey, the carvings being set off with gilding treated in various ways, both in matt and burnished. The marble fireplaces had beautifully chased mounts; marbles of all kinds being used. For chimneypieces and for interiors of rooms, staircases, etc., during the earlier part of the 17th century, black and white marbles were used alternately, giving very sombre effects. Later in the century, during the reign of Louis XIV., coloured marbles were introduced from Italy and Africa, and some of the old French quarries were reopened. This enabled the architects of the King and nobility to get some very rich effects, which can be seen at Le Louvre, Saint Germain, Fontainebleau, Versailles, etc. I have shown some of these marble rooms, staircases, etc.

Among the marbles utilised were Noir Antique, Verde Antique (Egyptian marble), Violet Brocatelle, Alabaster; Portor, a marble with deep yellow veins; Bleu Turquin, a deep blue; Lancquedocque, a deep red marble, veined with a darker self colour and greyish yellow colour; Griotte, a reddish speckled marble;

(Continued on page 298.)

Louis XV. **JACQUES-FRANCOIS BLONDEL.** Middle 18th Century.

Side of Room.

Louis XV. **JACQUES-FRANCOIS BLONDEL.** Middle 18th Century.

Trumeau or Mirror.

Chimneypiece.

Louis XV. JACQUES-FRANCOIS BLONDEL. Middle 18th Century.

Side of Room.
A, the recess to take double bed, with "Imperial" canopy; B, the place for the pillows; and C, the doors of the fitted wardrobes, with circular ends.

Side of Room—"Chambre de Parade."
A, part of the decoration of the large gallery; B, embrasure of the doors and cupboard; C, column grouped with a pilaster; D, support holding the balustrade, which separates the alcove from the "Chambre de Parade"; E, Lit de Parade, with an "Imperial" canopy; F, tapestry panels; G, cornice.

Louis XV. **JACQUES-FRANCOIS BLONDEL.** Middle 18th Century.

View of the Side of a Grand Salon.
A, doors of cupboards; B, glass panels; C, dado; D, tapestry panels; E, overdoors with panels; F, cornice.

Design for Side of Vestibule.

Louis XV. **CHARLES ETIENNE BRISEUX.** Middle 18th Century.

Design for Side of Room.

Louis XV. **CHARLES ETIENNE BRISEUX.** Middle 18th Century.

Design for Side of Room.

Louis XV. CHARLES ETIENNE BRISEUX. Middle 18th Century.

Design for Side of Room.

Brèche Violette, a notched pattern marble of browns and yellows, etc.; Jaune Fleuri, a yellowish marble with red veins, having a flowery effect; and many other varieties.

As regards the glass mirrors, they were made in Italy during the 16th century, and the workmen received State protection. It is said that Louis XIV. paid enormous sums for Venetian mirrors, spending as much as £10,500 on the Glass Hall of the Grand Trianon. It was

299

Louis XV. [CHARLES ETIENNE BRISEUX. Middle 18th Century.

Designs for Overdoors—Tapestry or Painted Panels.

Louis XV. **CHARLES ETIENNE BRISEUX.** Middle 18th Century.

Design for Chimneypiece and Panelling.

during Louis XIV.'s reign that glass chandeliers were such a conspicuous feature in the interiors of rooms. Glass being such an attraction is the reason for the great richness of some of the gilt frames made to enclose it. Colonies of Venetian glassmakers settled in France. They often made the mirrors over the chimneypieces, called "Trumeau," with an edge gently bevelled, an inch in width, following the forms of the frame. Marvellously

Design for Ceiling.

Louis XV. **CHARLES ETIENNE BRISEUX.** Middle 18th Century.

Design for Doors and Pier-shaped Glass, etc.

Design for Doors and Console Table, etc.

Louis XV. **CHARLES ETIENNE BRISEUX.** Middle 18th Century.

Design for Chimneypiece, etc.

Design for Chimneypiece and Doors, etc.

skilful were these workmen in the way they dealt with interrupted curves, short lines, angles, etc. They held the glass over their heads and the edge was cut by grinding. The French were very fond of glass rooms, the walls and even the ceiling being of this material. We had a minor instance of this style in this country in the house of Nell Gwynne, in St. James' Square, Pall Mall, where a back room was entirely lined with mirrors, including the ceiling.

Louis XV. **CHARLES ETIENNE BRISEUX.** Middle 18th Century.

Design for Chimneypiece and Candelabra.

Design for Chimneypiece and Candelabra, etc.

304
Louis XV. **FRANCOIS DE CUVILLES.** Middle 18th Century.

Designs for Stoves, etc.

Louis XV. **FRANCOIS DE CUVILLES.** Middle 18th Century.

Console Table and Glass.

Louis XV. **FRANÇOIS DE CUVILLES.** Middle 18th Century.

Designs for Balustrades.

Louis XV. **FRANCOIS DE CUVILLES.** Middle 18th Century.

Francois de Cuvilles, architect, decorator, and engraver, was born in 1698 at Soissons, Aisne, and died about 1767. He was a student of Robert de Cotte. He went to Germany, where he was much employed. He also planned parks and gardens. He had a son of the same name, who edited his numerous works on art and decoration.

The finials here shown are from a work published under the superintendence of Blondel, called "Regles des Cinq Ordres d'Architecture," by Jacques Barozio de Vignole. The engravings are by J. C. Pautre. Of course, the finials and the ironwork are additions by Blondel.

Among the woods native to France or neighbouring countries used during the 17th and 18th centuries, oak comes first, as it meets the requirements of the cabinet-maker in price, strength, and durability. It was extensively used in wainscotting, carved and gilt, the ground

Design for Finial.

Design for Ceiling.

Design for Finial.

Design for Ceiling.

Louis XV. FRANCOIS DE CUVILLES. Middle 18th Century

work in most cases being painted a light grey or other tint. Beech was also extensively used and birch was largely used in chair making. Among other woods utilised were chestnut, which is often mistaken for oak in old work, and is very durable; cherry, used for ebonising; hornbeam, a white wood with a fine grain; lime, largely used by carvers—a wood that Grinling Gibbons used for much of his work; pear tree, also used by carvers; boxwood, apricot, false acacia, elm; ebony of different shades from Ceylon; holly, used for stringing or inlaying work; poplar, in several varieties; walnut, cedar, cypress, pine; yew, which is hard and has a very fine grain, a capital wood for cabinet work and generally employed in the form of veneers; larch, rosewood, maple, apple, ash, beam, almond, mulberry, olive, etc., etc. Of course, after the middle of the century, mahogany and other woods, such as satin-wood,

Recessed Bed, showing Chantourné and Drapery.

Designs for Finials.

Louis XV. **FRANÇOIS DE CUVILLES.** Middle 18th Century.

and a host of others were imported into France.

Edmé Bouchardon, sculptor and architect, was born in 1698 and died in 1762. He won the Grand Prix de Rome in 1723. He spent ten years in Italy and returned in 1733. I have illustrated some of his work on pages 316 and 317. The statue of Louis XV. which formerly stood in the Place de la Concorde was by this artist; also the fountain in the Rue de Grenelle, Paris. The works of these old French masters are now fetching fabulous prices. In a sale held on May 24th,

(Continued on page 319.)

Designs for Bureaux.

Designs for Finials.

Louis XV. **FRANÇOIS DE CUVILLES—CEILING.** Middle 18th Century.

Design for Finial.

Design for Ceiling.

All Brass Clock at Versailles.

Design for Finial.

Louis XV. **BLONDEL.** Middle 18th Century.

Designs for Brackets and Pedestal to hold Vases.

Designs for Finials.
From Blondel's edition of Vignole's "Five Orders of Architecture."

Louis XV. **BLONDEL.** Middle 18th Century.

Useful Pieces of Ornament.

Panels and Pilasters in Ironwork.
From Blondel's edition of Vignole's "Five Orders of Architecture."

313

Louis XV. **BLONDEL.** Middle 18th Century.

Frontispiece to Blondel's edition of Vignole's
"Five Orders of Architecture."

Balcony and Balustrades in Ironwork.

Louis XV. Vase and Stand.

Louis XV. **PALAIS DE FONTAINEBLEAU.** Middle 18th Century.

The Salle du Conseil—Panel and Console Table.

Louis XV. **PALAIS DE FONTAINEBLEAU.** Middle 18th Century.

The Salle du Conseil.

Louis XV. **EDMÈ BOUCHARDON.** Middle 18th Century.

Louis XV. **EDMÉ BOUCHARDON.** Middle 18th Century.

318

Louis XV. **PALAIS DE VERSAILLES.** Middle 18th Century.

The Salle du Conseil.

Louis XV. **WALLACE COLLECTION.** Middle 18th Century. 319

1903, at Christie's, four pictures by Boucher, called "The Fortune Teller," "The Love Message," "Love's Offering," and "Evening," fetched 22,300 guineas. Again, in February, 1898, at a Cannes sale, five panels by Fragonard (a pupil of Boucher's), illustrating "Roman d'Amour de la Jeunesse," realised £50,000. On pages 314, 315, and 318 are given some illustrations of the Salle du Conseil at Fontainebleau, which was decorated by Boucher. The seats of the settees and chairs are covered with Beauvais tapestry of a Louis XVI.

Three Views of the Bureau du Roi.

Louis XV. **WALLACE COLLECTION.** Middle 18th Century.

Commode by Jacques Caffieri.

Parqueterie Commode with heavy Ormolu Mounts.

Parqueterie Commode with Ormolu Mounts.

design, although the frames are in Louis XV. style. A study of Boucher's easel pictures is not enough to give a correct idea of this artist's work, for he is chiefly distinguished as a decorative painter of walls and ceilings. The Salle du Conseil at Versailles, a view of which is given on page 318, dates from the second half of the reign of Louis XV. It was decorated by the sculptor Antoine Rousseau. On page 319 are three illustrations of a modern French copy in fac-simile, by Dasson, of the Louis XV. "Bureau du Roi," now in one of the 18th

321

Louis XV. **COMMODES.** Middle 18th Century.

Century Galleries of the Louvre. The original, in marqueterie of various woods, is adorned with mouldings, statuettes, vases, and plaques of gilt bronze, cast and chased. The original was begun in 1760 by Oeben, and completed in 1769 by Riesener. Its bronzes are by Duplessis, Winant, and Hervieux. The design and details show the transition between the periods of Louis XV. and Louis XVI. On page 320 is a commode in inlay of various woods, with mounts and ornaments of gilt bronze, cast and chased by Jacques Caffieri. In its class this is the most remarkable piece of furniture of this famous cabinet-maker and metal-chaser, who represents the earlier Louis XV. style at its best.

Mahogany Commode with Ormolu Mounts.

Commode with Ormolu Mounts and Lacquer Panels.

Rosewood Commode with Ormolu Mounts.

Louis XV. **WALLACE COLLECTION.** Middle 18th Century.

Monumental Clock.

Commode with Ormolu Mounts.

Commode with Ormolu Mounts.

The bronzes on this commode are busts of Roman emperors, and a group in the centre represents "Cupid Vanquishing Pan," with the inscription "Omnia vincit Amor." These bronzes are by Jean-Jacques Caffieri, who was born in 1723, and died in 1792.

Louis XV. INLAID MARQUETERIE TABLES, BUREAUX, ETC. Middle 18th Century.

323

Louis XV. CHÂTEAU DE CHANTILLY. Middle 18th Century.

Le Salon des Singes (Monkeys).

Louis XV. **MUSÉE DE LOUVRE.** Middle 18th Century.

Salon Louis XV.

Louis XV. INLAY. Middle 18th Century.

On the lower left hand side of page 320 is shown a parqueterie commode, mounted with massive ormolu chasing of oak branches and foliage, rising from the feet, and carried entirely over the front and ends. Two large figures of boys rest on the branches in front and numerous birds. Half-length figures of boys are at the angles, and the key plate is formed as a vase-shaped burning lamp, surmounted by moulded brocatella marble slab. At the lower right hand side is a parqueterie commode with ormolu mounts.

On page 322 a monumental clock of the "Régulateur" type is illustrated. It is signed "Alexandre, Fortier, invenit, Stollewerck fecit à Paris." The mounts are of gilt bronze, cast and chased, with decorative figures in gilt and dark bronze, the crowning group representing "Love and Time." The style is that phase of the Louis Quinze style which is connected with the name of Duplessis. The marqueterie panel in front and the gilt bronze garlands above and beneath it are of later date than the rest. Marqueterie reached a great degree of excellence during the last half of the 18th century, and such names as Riesener and David Roentgen are well-known. Riesener used tulip, rosewood, holly, maple, laburnum, purple wood, etc. Wreaths and bunches of flowers form centres of his marqueterie panels, which are often plain surfaces of one wood. On the sides in borders and compartments are found diaper patterns in three or four quiet colours.

David Roentgen made marqueterie in lighter woods and of rather a gayer tone than those of Riesener. Both worked in plain mahogany, and trusted for their effectiveness to the gilt metal

(*Continued on page* 334.)

Louis XV. **COACH FURNITURE AND SLEDGES.** Middle 18th Century.

Louis XV. **COACH FURNITURE.** Middle 18th Century.

Louis XV. **COACH, SEDAN CHAIR, AND SLEDGE.** Middle 18th Century.

Sledge by Meissonier.

Louis XV. **CHAIRS.** Middle 18th Century.

Louis XV. **SETTEES.** Middle 18th Century.

332

Louis XV. **IRON SCREEN AND FOUNTAINS.** Middle 18th Century.

No. 1.

No. 2.

Louis XV. **STATUES ERECTED TO LOUIS XV.** Middle 18th Century.

No. 3.

No. 4.

No. 5.

No. 6.

No. 7.

Illustrations on page 332:
 The iron screen is one of the fountains of the Place Royal at Nancy.
 No. 1, a triumphal fountain erected at Nancy.
 No. 2, a bronze statue of Louis XV., at Valenciennes, by M. Sally.

Illustrations on this page:
 No. 3, equestrian bronze statue of Louis XV., at Paris, by M. Bouchardon.
 No. 4, equestrian bronze statue of Louis XV., at Bordeaux, by M. Lemoine.
 No. 5, a bronze statue of Louis XV., erected at Nancy, by M. Guibal.
 No. 6, a bronze statue of Louis XV., at Rouen.
 No. 7, a bronze statue of Louis XV., erected at Reims, by M. Pigalle.

Louis XV. **BOUCHER.** Middle 18th Century.

Design by Boucher for Heading of one of M. Patte's Books.

mounts. Roentgen used pear, lime, and light coloured woods, occasionally tinted by burning, which is done either by hot irons or by hot sand, the latter being the best. Only dark yellows and browns are obtained by this process. Other tints, like greens and blues, are obtained by steeping the wood in chemical solutions. This marqueterie was often placed on a ground work of parqueterie, that is, the ground has veneers on one half or quarter of the panel going one way, and on the other half or quarter going the reverse way. I have shown a specimen of this style of inlay on page 326.

Among the makers of gilt bronze furniture mounts, Gouthière's name stands pre-eminent. He undertook various sorts of work—mounts to go on chimneypieces, carriages, furniture, etc. The gilding on these mounts is water gilt, probably double, and so

Louis XV. **LE PRINCE.** Middle 18th Century.

good and laid on so massively that it is almost as good as new.

The manufactory of Sèvres was called upon to supply plaques for some of the best furniture. These works were established at Sèvres in 1756. They owed much of their success to Madame de Pompadour, and the beautiful pink tint for which Sèvres is so famous is called "rose de Pompadour." According to Professor Church the fine coloured grounds were obtained as follows:—"The body, after having been baked, was glazed and fired. Then the colours were applied by dusting on to the glazed surface, which had been previously covered with a thin film of fat oil of turpentine. Then the pieces were fired, and the process of dusting on the enamel colour was repeated, the piece being fired again; repeating the process several times. The bleu du roi, often marbled and veined with gold, was in early use; the bleu turquoise was invented in 1752, and the rose carné or Pompadour, the violet pensée, the vert pomme, jaune clair (or jonquille), vert pré, and vert jaune in 1775. The special beauty of old Sèvres lies not in the intrinsic excellence of the enamel colours, though this is high, but in the penetration of the glaze by the enamel ground-colours, and the rich but soft effects thereby produced—an effect which is enhanced by the special qualities of the soft and fusible paste beneath." The porcelain of this date was "soft paste" or pâte tendre. The productions of the manufactory during the years between 1756 and 1769 are the most admired. Two L's interlaced is the Sèvres mark and a letter is added which marks the year in which the piece was made. The first alphabet begins in 1753 and ends in 1777 with the letter Z. The letters were doubled in 1778 and ended with RR in 1795.

336

Louis XV. **LOUIS XV. SALON AT THE LOUVRE.** Middle 18th Century.

337

Louis XV. **INTERIORS.** Last Half 18th Century.

Salon l'Œil de Bœuf, Versailles.

Chimneypiece by M. Patte.

Louis XV. **M. PATTE.** Last Half 18th Century.

Side of Room.

Chimneypiece.

Louis XV. **WRITING TABLES, ETC.** Last Half 18th Century.

Pierre Patte, architect and engraver, was born in 1723, and died in 1812. He continued the "Cours d'Architecture" of Jacques Francois Blondel, and published several works, among others "Monuments Erigés en France à la Glorie de Louis XV.," "Discours sur l'Architecture," "Etudes sur l'Architecture en France et en Italie," "Essai sur l'Architecture Théâtrale," etc.

Writing Table.

Writing Table.

Candelabrum.

Louis XV.—Louis XVI. **ROUBO.** Last Half 18th Century.

Lit de Parade by Roubo.

Lady's Table.

At top of page 339 is an illustration of a writing table of Louis XV. period in Riesener marqueterie of various woods and floral inlay, with curved top and legs, and heavy mountings in chased ormolu. It has three drawers. This table was formerly in the Angerstein Collection, and is stamped "Petit." Height, 2 ft. 6½ in.; length, 5 ft. 1 in.; width, 2 ft. 11 in. On the left is shown a table on similar lines to above. To the right is a beautiful Louis XV. candelabrum.

On this page and the next interiors by Roubo about the year 1770 are illustrated.

On this page also a very pretty table suitable for a lady, inlaid with marqueterie of bunches of flowers on a ground of rosewood, is shown. It has a brass gallery round the top, and also has a flap underneath to pull out.

On page 341 is shown a small bureau with sloping top, inlaid with bunches of flowers and various other ornaments in marqueterie on rosewood and satin-wood. It is enriched with beautifully chiselled brass mounts gilt, composing the shell work and foliage of the pinceaux. It is stamped with the C crown, which is said to be Caffieri's mark.

On page 342 an alcove for bed, etc., after the Louis XVI. style, is illustrated. At the bottom left-hand corner is shown a large bureau in the Wallace Collection. To the right is shown a fancy table with brass gallery and ormolu mounts and flutes.

On page 343 in top left-hand corner is an illustration of an escritoire à toilette. It is made of tulip and sycamore, inlaid with a landscape, trophies, vases, and flowers, in plain and tinted

Louis XV.—Louis XVI. **ROUBO.** Last Half 18th Century.

lime or holly and cherry. The design of the piece is curved, and the mountings are chased ormolu. The front of the escritoire is cylindrical and encloses drawers with inlaid fronts. Beneath this is a sliding shelf, under which is a drawer with three compartments, with inlaid lids, two of which are fitted with toilet requisites. It was probably made by Jean-Francois Oeben. This exquisite specimen of cabinet work formerly belonged to Queen Marie Antoinette. It belongs to the period of Louis XV. Height, 3 ft. 5 in.; width, 2 ft. 6 in. In the right-hand corner on the same page is a bureau-toilette in marqueterie of various woods. The mounts are of gilt bronze, cast and chased. Also probably by Oeben, and belongs to the early part of the transition period between the Louis Quinze and Louis Seize styles. The picture cannot do justice to this exquisite piece of work, and it is only shown to give the general proportions. The effect of the woodwork and the elaborate and beautiful inlay is very light, almost pale. On top is a statuette in gilt bronze of Minerva, armed with spear and shield, which belongs to the first half of the 18th century. At the bottom of the page is shown a bureau with very heavy mounts. The inlays are said to be by Riesener.

On page 344 is a commode of ebony, decorated throughout with panels of Japanese lacquer, framed in mounts and ornaments of gilt bronze, cast and chased. It rests upon legs formed by the figures of sea-nymphs bearing cushions on their heads. The panels of lacquer are half covered with zigzags and circular wreaths of roses in gilt bronze. Over the lower part of the central panel is a group, in low relief, of doves amorously pecking as they rest on Cupid's quiver. The edges are enriched with hanging garlands of roses and other flowers in gilt bronze. It is signed "J. Dubois." This piece, which has the shape of a coffer or chest, has been described as the "Coffre de Mariage

Console Table and Glass.

Marqueterie Writing Bureau with Ormolu Mounts.

342

Louis XV.—Louis XVI. **INTERIOR AND TABLES.** Last Half 18th Century.

Alcove for Bed.

Bureau in Wallace Collection. Fancy Table.

343

Louis XV.—Louis XVI. **WRITING TABLE AND COMMODES.** Last Half 18th Century.

Escritoire à Toilette. Bureau-Toilette.

de la Dauphine Marie-Antoinette," and was made in the last years of the reign of Louis Quinze, in the so-called Louis Seize style. On this commode in centre is a perfume burner in the form of a tripod. The bowl and stand are of red jasper ("jaspe rouge fleuri"). The mounts are of gilt bronze, cast and elaborately chased, showing satyrs' heads, from which hang festoons of vine, and, within the feet, a serpent coiled to spring, and are probably by Gouthière. It was No. 25 in the sale of the Duc d'Aumont's collection in 1782, when it was purchased by Le Brun for 12,000 francs on behalf of Queen Marie-Antoinette. In the catalogue of the sale this piece is described as "un chef d'œuvre de l'art." Also on top of this commode are a tazza in tripod form, with bowls and stands in distinct varieties of red marble, and mounts of gilt

Bureau.

344

Louis XV.—Louis XVI. **COMMODES.** Last Half 18th Century.

Commode in the Wallace Collection.

Commode in the Victoria and Albert Museum.

Candelabra.

Louis XV.—Louis XVI. **COMMODES.** Last Half 18th Century.

bronze and chased, of the style and period of Louis Seize. On the same page is illustrated a commode of oak, veneered with tulipwood and enriched with marqueterie of harewood, sycamore, and other woods. The mounts are of chased ormolu. On the top is a slab of variegated red and yellow marble. It is stamped R.V.L.C. ME (nuisier), is of the early period of Louis XVI., late 18th century, and is in the Victoria and Albert Museum. The candelabra are by De la Fosse of the Louis XVI. period.

Commode in the Victoria and Albert Museum.

At top of this page is shown a commode of oak, with marqueterie of tulip, king, and other woods. The serpentine front is decorated with three panels, filled in with a trellis pattern having ormolu studs at the points of intersection. These panels are outlined by ormolu borders with incurved corners, filled in with rosettes. The curved sides are ornamented with similar panels. At the front corners are terminal figures in ormolu of Cupid and

Commode in the Victoria and Albert Museum.

Psyche, the former holding a dove and the latter a bunch of flowers. Each of the two drawers has two ormolu handles, and below the centre panel is a group in the same metal, consisting of a reclining female figure between two children, one offering her a wreath and the other holding a dove. The top is of variegated

Louis XV.—Louis XVI. **COMMODES.** Last Half 18th Century.

Commode.

Candelabrum.

red *griotte* marble, and the whole is supported on four curved legs with ormolu mounts. This commode belongs to the end of the Louis XV. period, second half of 18th century. Height, 2 ft. 9 in.; width, 4 ft. 2¾ in.; depth, 2 ft. 2 in. It was bequeathed to the museum by the late Mrs. Lyne Stephens.

Jewel Cabinet. Commode in Victoria and Albert Museum.

347

Louis XV.—Louis XVI. **UPRIGHT SECRÉTAIRE.** Last Half 18th Century

At the bottom of page 345 is a commode of marqueterie of various woods, the centre panel of the front inlaid with a vase of flowers. It contains five drawers, has a top slab of white marble, and mountings of chased ormolu. It belongs to the period of Louis XV. Height, 2 ft. 11 in.; length, 4 ft. 6½ in.; width, 23 in. The candelabrum on page 346 is by De la Fosse, and belongs to the Louis XVI. period.

On top of page 346 is a cabinet in marqueterie and with ormolu mounts, beautifully chased and gilt. At the bottom left-hand corner is a commode in mahogany and sycamore, with geometrical inlay in lighter woods, grey marble top, and mounts of chased ormolu. It has two drawers. It is stamped "P. Denizot," the mounts being probably by Gouthière, and is of the period of Louis XVI. Height, 2 ft. 11 in.; width, 3 ft. 1 in.; depth, 20 in. At the right-hand corner is a jewel cabinet in marqueterie of geometrical inlay in rose and sycamore wood, with chased ormolu mountings. The upper part has a rising lid with internal trays; in the lower part is a drawer and a shelf. It is stamped "J. H. Riesener," and the metal work is by Gouthière, also of the period of Louis XVI. Height, 3 ft. 6 in.; width, 21 in.; depth, 12 in.

Upright Secrétaire.

Above is an illustration of an upright secrétaire in marqueterie of various natural and stained woods. The mounts and ornaments are of gilt bronze, cast and chased. The central panel of marqueterie shows, in life size, a cock, with the caduceus, and snake, a banner, and symbolical instruments. This secrétaire is

Louis XV.—Louis XVI. **UPRIGHT SECRÉTAIRE.** Last Half 18th Century.

Upright Secrétaire.

Barometer.

Mahogany Commode with Ormolu Mounts.

by Riesener, and in his earlier manner. It was made in the later years of the reign of Louis Quinze, in the transitional style approaching to the so-called Louis Seize.

On top of this page is illustrated an upright secrétaire with brass mounts of a Louis XVI. character. To the right of this is a barometer in a case of chased ormolu, with plaques of Sèvres porcelain. It is signed: "**Passemant au Louvre,**" and is of the late period of Louis XV., second half of 18th century.

COMMODES. Last Half 18th Century.

Louis XVI.

It is in the Victoria and Albert Museum. At the bottom of the same page is shown a mahogany commode with beautifully chased and gilt brass mounts.

On this page is shown a mahogany commode with beautifully designed ormolu mounts, and below in the left-hand corner is a cabinet in marqueterie of tulip, box, and purple wood, decorated with plaques of Sèvres porcelain, painted with flowers on a white ground with borders of green. The mounts are of gilt bronze, cast and chased. This cabinet is by Martin Carlin, and is of the style and period of Louis Seize. In the right-hand corner is a commode attributed to J. F. Leleu, with beautifully chased and gilt brass mounts.

Mahogany Commode with Ormolu Mounts.

Cabinet in the Wallace Collection. Commode.

Louis XVI. **UPRIGHT SECRÉTAIRES.** Last Half 18th Century.

Upright Secrétaires.

Above are given two illustrations of upright secrétaires by Riesener of the style and period of Louis Seize. The plaques and mounts, ornaments, and floral decorations are in gilt bronze, cast and elaborately chased, and are by Gouthière. That on the left is in satin-wood and marqueterie of various woods, and is stamped on the back with the cypher of Queen Marie-Antoinette and the Royal Crown encircled with the words: "Garde-Meuble de la Reine." That on the right is in amboyna wood, with purple-wood bands.

On page 351 is an illustration of a cabinet of oak and pine, veneered with ebony and enriched with Sèvres plaques. The inside of the cupboard is of satin-wood and the long drawer of mahogany. The mounts are of ormolu. On the top is a slab of variegated yellow marble. It is stamped "E.H.B.," and is in the style of the period of Louis XVI. Modern French. It is in the Victoria and Albert Museum. On the same page is illustrated a music-stand or reading table in marqueterie, with rising top inlaid with a Sèvres plaque which

Louis XVI. **CABINET AND MUSIC STAND.** Last Half 18th Century.

has the date letter for 1778. It is on a tripod stand, with mountings of chased ormolu. It has a drawer fitted for writing purposes. This music stand is stamped " M. Carlin," and formerly belonged to Queen Marie-Antoinette, by whom it was given, in 1786, to Mrs. Eden, afterwards Lady Auckland.

On top of page 352 is shown a table in satin-wood and purple-wood, with mounts and ornaments of gilt bronze, cast and chased, the main feature of the decoration being rich detached festoons of oak leaves and acorns, of the style and period of Louis Seize. On this table in the centre is a turret-shaped clock of

Cabinet.

Music Stand.

gilt bronze, the dial ornamented with paste diamonds. The crowning decoration is a figure of Love, with the emblems and trophies of War. This clock is of the same style and period. At each side are bronze statuettes belonging to the middle of the 18th century. They represent Cupid with his bow and arrows and the infant Bacchus with a thyrsus and wine cup. Also on this table are candelabra of gilt bronze, cast and chased, showing figures of Love uplifting large stems of lilies, of the style and period of Louis Seize. At the bottom of the page is a candelabrum of lapis-lazuli quartz and gilt bronze, cast and chased. The form is that of a tripod supported by sphinxes of French 18th century type. Within the tripod is coiled a serpent. The ornamentation comprises

352

Louis XVI. **TABLE, CANDELABRUM, AND GUÉRIDON.** Last Half 18th Century.

Guéridon in the Wallace Collection.

Table in the Wallace Collection.

Candelabrum.

goats' heads, other sphinxes' heads of a more Egyptian type, and flowers realistically treated. This is by Gouthière, and of the style and period of Louis Seize. The candelabrum stands on a triangular Louis Seize guéridon of mahogany and gilt bronze, cast and chased, in the style of Martin Carlin. The candelabrum is by De la Fosse; of Louis XVI. period.

353

Louis XVI. **PIERRE-GABRIEL BERTHAULT.** Last Half 18th Century.

Designs for Vignettes, engraved on Copper, by Saint Mon, suitable for Marqueterie Panels.

·W

Louis XVI. Last Half 18th Century.

JEAN SIMÉON ROUSSEAU DE LA ROTTIÈRE.

Ceiling of Boudoir.

On page 353 will be found some useful designs for groups of flowers, etc., suitable for marqueterie panels in the Louis XVI. style by Pierre Gabriel Berthault.

Above is an illustration of a ceiling decorated with a circular medallion in the centre, enclosing a figure of Jupiter and his eagle amid clouds, painted by Jean Jacques Lagrenée *dit* le Jeune. This artist was born in 1740 and died in 1821. In each spandrel of this design is a moulded and gilt eagle in a wreath. Each of the coved sides has a classical figure within a circular medallion in the centre, between two carved amorini terminating in gilded scrolls; in the corners are shells and wreaths. This ceiling forms part of a boudoir which was formerly in the Rue Vieille-du-Temple, No. 106, Paris, and was constructed for Madame de Serilly, lady-of-honour to Queen Marie Antoinette. It is now in the Victoria and Albert Museum, and is of the period of Louis XVI.

Louis XVI. Last Half 18th Century.
JEAN SIMÉON ROUSSEAU DE LA ROTTIÈRE.

Side of a Boudoir.

Candelabrum.

Above is shown a side of the same boudoir, with a chimneypiece of grey marble, the jambs of which are carved with muffled terminal figures by Claude Michel Clodion. Above is a lunette containing a figure of Pomona, painted by Jean Jacques Lagrenée. On either side is a pilaster painted with arabesques by Jean Siméon Rousseau de la Rottière, within carved and gilt oak mouldings. Clodion was born in 1738 and died in 1814.

A candelabrum, one of a pair, for three lights, is also illustrated above. Two bronze draped females supporting an ormolu vase from which spring foliated brackets and spirals of ivy, on cylindrical stand of marble and chased ormolu. Probably by Pajou or Falconet. Height 3 ft. 7 in.

Louis XVI. **PALAIS DE FONTAINEBLEAU AND PETIT TRIANON.** Second Half 18th Century.

Boudoir of Marie Antoinette.

Bedroom of Marie Antoinette in the Petit Trianon.

357

Louis XVI. **PALAIS DE FONTAINEBLEAU.** Second Half 18th Century.

Door of Marie Antoinette's Boudoir.

Louis XVI. **PALAIS DE FONTAINEBLEAU.** Second Half 18th Century.

Bedroom of Marie Antoinette.

Louis XVI. **CHARLES DE WAILLY.** Second Half 18th Century.

Design for Ceiling.

Louis XVI. **CHARLES DE WAILLY.** Second Half 18th Century.

Louis XVI. **CHARLES DE WAILLY.** Second Half 18th Century.

Louis XVI. **J. B. GREUZE AND J. E. NILSON.** Second Half 18th Century.

By Greuze.

Designs for Frames by Nilson.

On pages 359, 360, 361 will be found some designs by Charles de Wailly. He was born in 1729 in paris, and he studied under Blondel. He has been called the "Palladio" of France. These are somewhat ambitious designs, but many other designs of Louis XVI. interiors are shown in this volume.

Above is a picture by J. B. Greuze. He was born in 1725 and died in 1805. Some designs for frames by J. E. Nilson are also shown, which were probably made about 1770. On page 363 are some designs

Louis XVI. **FRAGONARD.** Second Half 18th Century.

364

Louis XVI. **J. M. MOREAU LE JEUNE.** Second Half 18th Century.

Interior with Figures.

Clock with Lyre.

Frieze of Chased Brass Work.

Louis XVI. CANDELABRA. Second Half 18th Century.

by Honoré Fragonard, who was a pupil of Boucher. He was born in 1732 and died in 1806. On page 364 will be found an interior showing the costumes of the time, also a clock of Sèvres porcelain frame, lyre shape, gros-bleu, with chased ormolu mounts, the dial painted with the signs of the Zodiac by Cotteau, and the pendulum formed by a ring of paste diamonds. The works are by Kinable, and the metal mounting by Duplessis. Length, 2 ft. ¼ in.; width, 10½ in.

On this page some candelabra are illustrated. No. 1 has six branches, and is from the Petit Trianon.

No. 2 is one of a pair, for three lights, of chased ormolu; two female figures, supporting a vase, from which spring branches of lilies, and resting on an oval base with festoons of flowers and gadroons. Middle of 18th century. Height, 23¼ in.

No. 3 is also for three lights, one of a pair, of bronze and ormolu; a female figure holding a cornucopia and standing on a marble pedestal. Late 18th century.

No. 1.

No. 2. No. 3. No. 4.

Louis XVI. **SETTEE, CHAIR, AND TABLE.** Second Half 18th Century.

No. 4 is also one of a pair, for three lights. Gros-bleu Sèvres porcelain vase mounted in chased ormolu, with floral branches for the lights, and marble base. About 1760. Height, 23½ in.

On page 367 is an armchair of white walnut, carved with leaves, floral sprays, rosettes, and bands of leaf and astragal ornament. The back, seat, and arms are stuffed, and covered with Beauvais tapestry of late 18th century. The subject on the back is a landscape with a woman with a basket of flowers and a boy. The subject on the seat is a man fishing, accompanied by a woman. The arm chair is supported on four fluted legs with similar carving, and the whole of the woodwork is covered with gilding. The woodwork is 19th century. Height, 3 ft. 3⅜ in.; width, 2 ft. 3⅛ in.; depth, 22 in. A similar armchair of white walnut, carved with leaves, floral sprays, rosettes, and bands of leaf and astragal ornament is shown on the same page. The back, seat, and arms are stuffed, and covered with Beauvais tapestry of late 18th century. The subject

Chair in Beauvais Tapestry.

Settee in Beauvais Tapestry.

Gilt Round Table. Green Granite Top and Base.

367

Louis XVI. **CHAIRS IN BEAUVAIS TAPESTRY.** Second Half 18th Century.

on the back is a landscape with a love-scene, the figures being in "Watteau" costume. The subject on the seat is also a landscape with a youth pouring flowers into the lap of a maiden. The armchair is supported on four fluted legs with similar carving, and the whole of the woodwork is covered with gilding. The woodwork is of the 19th century. Height, 3 ft. 3⅜ in.; width, 2 ft. 3¼ in.; depth, 20 in. Both these chairs were bequeathed by the late Mrs. Lyne Stephens.

Louis XVI. **VERSAILLES.** Second Half 18th Century.

Reception Room of Marie Antoinette.

Grand Salon of the Queen Marie Antoinette in the Petit Trianon. Louis XVI. Clock.

Louis XVI. **PALAIS DU PETIT-TRIANON.** Last Half 18th Century.

Cheminée du Grand Salon.

Louis XVI. **BEDSTEAD AND DRESSING-TABLE.** Last Half 18th Century.

Dressing Table.

Among the woods used during the 18th century, besides those already mentioned, are mahogany, satin-wood, thuyawood, citron, amaranth, snakewood; violet, white, green, and several other kinds of ebony; cinnamon, cedar, cypress, purplewood, boxwood, tulipwood, amboyna, kingwood, sycamore, harewood, rosewood, and various other woods from Asia, America, etc.

A carriage painter named Vernis-Martin invented a process which is named after him. He was born in 1706.

Bedstead of Carved and Gilt Wood, with coverings of Blue Silk Damask.

Louis XVI. **LALONDE.** Last Half 18th Century.

Vernis-martin is a sort of varnish of a fine transparent lac polish, said to have been derived from Japan through the missionaries. It is generally found on small articles, such as snuff-boxes, needle-cases, fans, etc., on a gold ground, but is sometimes used in panels of furniture. The gold is waved or striated by some of those ingenious processes still in use amongst the Japanese, by which the paste or preparation is worked over while still soft. The panels are sometimes coloured green and varnished. Among the velvets, silks and damasks in use at the beginning of the 17th century were

(*Continued on page* 379.)

Designs for Bedsteads.

372

Louis XVI. **PALAIS DE FONTAINEBLEAU.** Last Half 18th Century.

Le Salon de Musique.

373

Louis XVI. **PALAIS DU PETIT-TRIANON.** Last Half 18th Century.

Tables, Chairs, Vases, etc.

Louis XVI. **CHAIRS.** Last Half 18th Century.

Louis XVI. **SETTEES.** Last Half 18th Century.

376

Louis XVI. **DESPREZ AND SALEMBIER.** Last Half 18th Century.

Side of Room by Desprez.

Friezes by Salembier.

Louis XVI. **SETTEE, CHAIRS, ETC.** Last Half 18th Century.

Carving at Victoria and Albert Museum.

Chairs, etc., from the Boudoir of Marie Antoinette at the Palais de Fontainebleau.

Carving at Victoria and Albert Museum.

Louis XVI. **LALONDE.** Last Half 18th Century.

Louis XVI. **LALONDE.** Last Half 18th Century.

the "lopped bough" patterns and "bound branch" patterns—the latter two branches ending in flowers bound together. They are usually on a gold ground, but other grounds were used—"patterns of flowers disposed in opposite directions." This floral type of ornament is always the same whether it occurs in velvets, brocade, or damask. One flower turns to the right in the first row and to the left in the second, and so on. "Suspended floral" patterns is another form of ornament much used about this time. "Spiral scroll" patterns are attributable to the Renaissance, and were copied from the volute scroll of the Ionic column. Gold and silver thread was worked with silk, etc., in the richer pieces. Venice and Lyons copied Chinese patterns, but altered them to suit local taste. It was during the 17th century that the walls, the high back walnut chairs, and the hangings for beds were covered with those "flowerbed sort of patterns," samples of which can be seen at Hampton Court Palace. These were mostly made in velvet for furniture, at Lyons, as well as in Italy. Another recognised pattern of silk is the "vase" pattern. This was also made at Lyons during the 17th century. "Flowered lace" patterns, where the flowers are placed vertically on the edge of a piece of lace, having pomegranates or other fruit placed here and there, and "lace" patterns were also in vogue. Birds and moths, etc., were used to enrich some of these fabrics, the idea being copied from the Chinese. Flat embroidery patterns were worked on the surface only, with fine gold and silver threads. Among the popular patterns manufactured at Lyons were figured damasks with the "twining ribbon reversed." Other patterns are the "ribbon and serpentine stripe" (Louis XV.); "entwined ribbon" pattern, often associated with medallion portraits (Louis XVI.), also made at Lyons; "twining branch and serpentine" pattern (Louis XVI.), and the "straight stripe" pattern. These simple stripes, strewn with flowers, belong to the end of the reign of Louis XVI., but were continued during the Republic and the Consulate. The Empire patterns have the laurel wreath, the bee, the Greek vase, various pieces of Greek ornament, like the honeysuckle, swags, stars, the lyre, and various other emblematic designs reminiscent of classic art.

380 Louis XVI.					LALONDE.					Late 18th Century.

Console Table.

Cabinet Console Table.

Chimneypiece.

Louis XVI. **LALONDE.** Late 18th Century.

Chimneypieces.

Louis XVI. **LALONDE.** Last Half 18th Century.

383

Louis XVI. **LALONDE.** Last Half 18th Century.

Charles De la Fosse was born in 1721 and died in 1790. His designs are somewhat heavy in character, wreaths being thrown over articles, giving them a clumsy look. In the designs of some smaller articles, such as fire-dogs, hanging clocks, etc., however, he shows great taste. Lalonde published a great many designs for furniture, and I have shown a number of them, as they are thoroughly representative of what was in vogue during the latter half of the 18th century. Salembier designed a great deal of ornament of a very light and elegant description. I have shown a few of these also.

Louis XVI. **CANDLESTICKS BY LALONDE.** Late 18th Century.

385

Louis XVI. **COMMODES.** Last Half 18th Century.

Commode designed by Lalonde.

Ornament by Salembier

Ornament by Salembier.

Commode with Ormolu Mounts, emblematic of War.

Louis XVI. **PERCIER AND FONTAINE.** Last Half 18th Century.

Various Designs for Furniture.

Ornament by Charles Normand.

Louis XVI. **CHARLES NORMAND.** Last Half 18th Century.

Vases by Charles Normand.

Vases by Charles Normand.

Vase by Jacques Saly.

Empire Style. **NAPOLEON'S THRONE.** Early 19th Century.

389

Empire Style. **PERCIER AND FONTAINE.** Early 19th Century.

Bedstead.

Napoleon's Throne.

Empire Style. **CHAIRS.** Early 19th Century.

The Empire style is founded on the ancient Roman and Greek styles. After the Italian wars and the Egyptian expedition were over, the French seem to have turned towards an assumption of classicalism —imitating the old classical ideals — and carrying it so far as to imitate in the shape of the backs of their chairs, etc., the Roman bas-reliefs and drawings on antique vases. The occasional introduction of the Sphinx, as in the arms of the chairs shown on these pages, was meant to remind people of the French expedition to Egypt. Furniture was made in mahogany, rosewood, and ebony, with brass mounts, or the carved ornaments were gilt. Another mode was to inlay the wood with metal and ivory. These methods of inlaying in metal on a ground of ebony or dyed wood seem peculiarly adapted to the nature of the mahogany furniture so much in use at that time, which they enliven, without preventing it by any raised ornament from being kept free from dust and dirt. This style of ornamentation was carried to a great degree of

Empire Style. **CHAIRS.** Early 19th Century.

elegance and perfection. The metal ornament and the ground of stained wood in which it is inserted, being stamped and cut out together, are always sure to fit each other to a nicety. Among the noticeable features of the style are winged figures emblematic of Liberty, antique heads of helmeted warriors arranged like a cameo medallion, mouldings representing antique Roman faces with an axe in the centre; trophies of lances, surmounted by a Phrygian cap of Liberty. Vases found in tombs were placed in recesses imitating the ancient columbaria, or receptacle of the cinerary urn. Other subjects chosen were an Indian or bearded Bacchus, the scenic mask, the thyrsus, twined round with ivy leaves, the panther's muzzle and claw, with other insignia of Bacchus;

(Continued on page 394.)

Empire Style. **PERCIER AND FONTAINE.** Early 19th Century.

Empire Style. **PERCIER AND FONTAINE.** Early 19th Century.

Empire Style. **SETTEE.** Early 19th Century.

chimeras gilt or in bronze after the Roman style, also bronze candelabra, copied from examples that were excavated from Pompeii.

Among the artists who are credited with influencing the Empire style was David Jacques, who is accused of pandering to the Cæsarism of Napoleon. Percier

Lampadaire.

Empire Style. **SETTEE.** Early 19th Century.

and Fontaine published a work on Furniture, etc. Charles Percier was born in 1764 and died in 1838. He won the Premier Grand Prix de Rome in 1786. He appears to have supported himself during the French Revolution by designing furniture and decorations, introducing classical features. Pierre Francois Leonard Fontaine was born in 1762 and died in 1853.

(Continued on page 399.)

Lampadaire.

Empire Style. **JEWEL CABINET.** Early 19th Century.

A Jewel Cabinet, in Rosewood with Brass Mounts, richly gilt and chased.

Empire Style. **COMMODES, TABLES, ETC.** Early 19th Century.

Empire Style. **ROOM AT THE GRAND TRIANON.** Early 19th Century.

399

Empire Style. **NAPOLEON'S BED AT THE GRAND TRIANON.** Early 19th Century.

Ornament by Charles Normand.

Napoleon's Bed at the Grand Trianon, Versailles.

Percier and Fontaine had a large practice. Their work on Furniture is called "Recueil des Décorations Intérieures," published in 1812. It is regarded as the standard work on the Empire style of Furniture.

They were made directors of the decorations of the Opera House. When Napoleon became First Consul they were appointed his architects. They designed and built the Arc de Triomphe du Carrousel. Fontaine published a "Histoire du Palais Royal."

Charles Pierre Joseph Normand was born in 1765 and died in 1840. He devoted his time during the French Revolution to engraving architectural subjects, and was a most prolific and conscientious worker. He had studied in Italy, having won the Premier Grand Prix de Rome in Architecture. His great work is "Nouveau Parallèle des ordres d'Architecture," published in 1819.

Empire Style. **CHARLES NORMAND.** Early 19th Century.